Doug Box's

GUIDE TO POSING

FOR PORTRAIT PHOTOGRAPHERS

AMHERST MEDIA, INC. ∎ BUFFALO, NY

Published by:
Amherst Media®
P.O. Box 586
Buffalo, N.Y. 14226
Fax: 716-874-4508
www.AmherstMedia.com

Publisher: Craig Alesse
Senior Editor/Production Manager: Michelle Perkins
Assistant Editor: Barbara A. Lynch-Johnt
Editorial Assistant: John S. Loder

ISBN-13: 978-1-58428-248-8
Library of Congress Control Number: 2008926668
Printed in Korea.
10 9 8 7 6 5 4 3 2 1

Contents

About the Author

Doug has been inspiring photographers of all levels to go beyond the normal studio into a more successful and creative business. Besides being an excellent photographer, he is a dynamic and entertaining speaker and has appeared in a wide variety of seminars and conventions in forty-seven states in the United States, as well as in Canada, China, England, Mexico, Scotland, and Wales. He was also chosen to teach at the International Wedding Institute by Hasselblad University. His fun and genuine style of teaching will help you learn to be a better photographer.

Doug's articles and images have graced the pages of numerous professional photographic publications. He is the author of the *Photographic Success Newsletter* and has written several books, including *Professional Secrets for Photographing Children* (2nd ed.; 2002), *Professional Secrets of Wedding Photography* (2nd ed.; 2003), and *Professional Secrets of Natural Light Portrait Photography* (2001), all published by Amherst Media. He has a series of DVD learning systems covering many aspects of photography and is the owner of Texas Photographic Workshops, a year-round educational facility offering hands-on and web-based photographic learning. For more information on any of the learning opportunities, visit www.texasphotographicworkshops.com.

Introduction

The Purpose of Posing

Merriam-Webster's Collegiate Dictionary defines "pose" in the following ways:

- to put or set in place
- to place (as a model) in a studied attitude
- to assume a posture or attitude usually for artistic purposes
- to affect an attitude or character usually to deceive or impress

Well, I believe what we do as photographers is capture our subjects as they are *or* as they wish to be. I love the last line of the definition, "to affect an attitude or character." That is what our subjects want us to do. If we are not good with our—for the lack of a better description—"bedside manner," we can cause our subjects to look stiff or unnatural. In addition to learning how to use our camera's features, ensuring great lighting, and carefully composing our images, we need to learn how to make our subjects feel comfortable, so they will look natural when posed in front of the camera. There is as much psychology in making great photographs as there is science. We will talk about all of that in this book.

In the chapters that follow, we will look at the art and science of posing. You'll learn how to present the body to flatter your subject's physique and how the composition and lighting should work with the pose to draw and hold the portrait viewer's attention. You'll learn tips and tricks for working with individuals, couples, and groups—as well as strategies for finessing photos of men, women, and children. The book features a wide array of images of a variety of subjects—posed in-

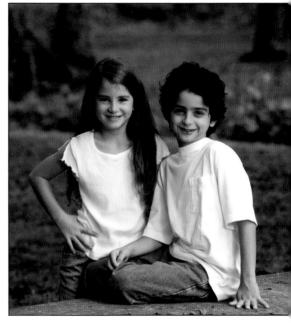

A great pose helps to make the subjects look their best and adds visual interest in the portrait. In group portraits, the pose also helps to describe the relationship between the subjects.

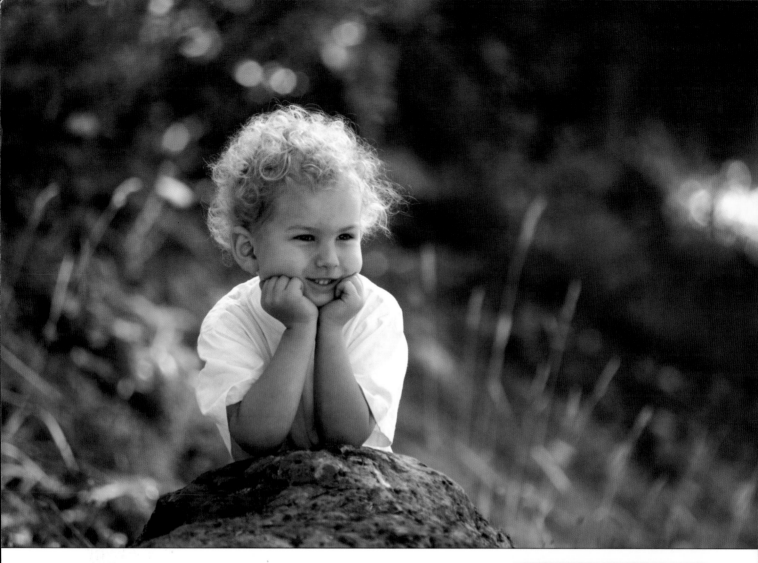

doors and out. Let the images seen in these pages inspire your work with your own clients.

The Mona Lisa

The *Mona Lisa* is the most famous, most beautiful, and most valuable portrait in the world. So, should we use it as a standard for all portraits? I submit several of my images each year in contests. I wonder what the judges would say if this image was entered today. Some might say, "Lovely subject, nice direction of light, good composition." Others might say, "The background is too busy, the artist is showing the back of the hand (the edge of the hand is a more pleasing angle to show), and there is no flow to the pose." But how do you argue with the success of this masterpiece? There is an old saying in the portrait photography business, "Beauty is in the eyes of the checkbook holder!"

My thinking is, if you like the portrait and the subject, or your client likes the portrait, it is a beautiful portrait.

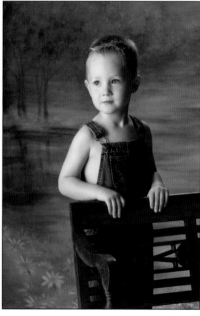

Traditional or contemporary? Casual or formal? A great pose captures the "essence" of the subject and helps to establish the mood of the portrait.

Posing Basics

The Goal

The goal of any pose is to flatter the subject. The pose should appear natural to the subject. The subject should appear relaxed and comfortable. Because we are portraying a three-dimensional subject in a two-dimensional medium, we must be careful to follow some basic rules to show shape and form and to prevent distortions in the subject's features. In the pages that follow, we'll take a look at some simple strategies that all photographers can adapt, with every client, to take a significant step toward creating better portraits.

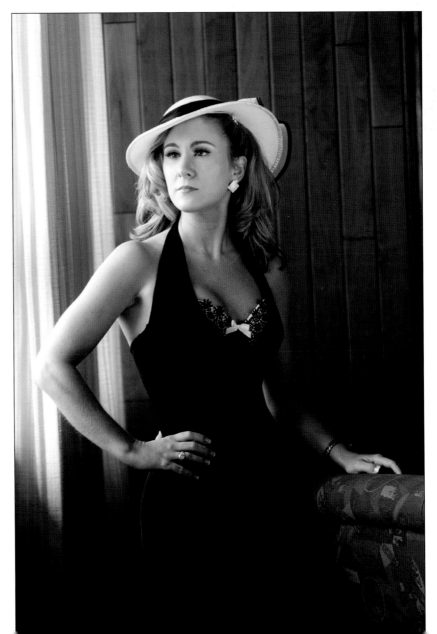

A good pose helps to create a sense of a third dimension in a two-dimensional image, flatters the form, and discourages distortion.

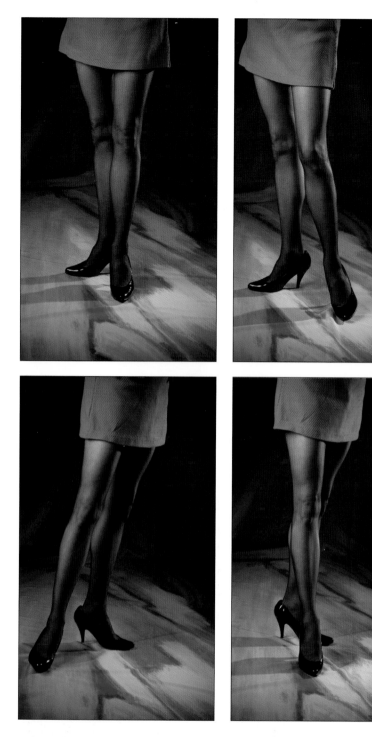

The way that the subject's feet are posed affects the line of the whole body and, therefore, you should be sure to carefully position your client's feet—even if you do not plan to show them in the final image. **Left**—This is the basic foot position for the basic pose. **Right**—To add a little more flow to the pose, have the subject move the front foot away from the light, then turn the knee slightly toward the light. In both of these images, the light is coming from the left. If this were a full-length image, you would see that her face was turned toward the left.

Left—Here is the basic foot position used for the feminine pose. In the feminine pose, the body is turned away from the light and the face is turned toward the light. Note that in these images, the main light was placed to the left. **Right**—Here, we have enhanced the lines of the feminine pose by moving the front foot closer to the light, and bending the knee away from the light.

Start with the Feet

A good pose starts with a strong foundation. When posing your subject, you must pay attention to the feet—whether or not you plan to include them within the photographic frame. In a typical pose, I will have the person stand with their weight on their back foot (the one farthest from the camera). This lowers the back shoulder and shifts the line of the hips, giving some flow to the body and creating a more dynamic, appealing line.

My friend and fellow photographer, Ralph Romaguera, has a "twosey" law. Any body part that a person has two of—e.g., eyes, hands, shoulders, feet, etc.—should be positioned at different levels. It is a good rule. When every part of the body is on the same level, the body—and the overall image—looks stagnant and boring.

Posing and Lighting

Without light, there would be no portrait. Of course, the quality of light and the way in which the body relates to the light have an important affect on the success of the portrait. Though this book is about posing, the topics of light and pose are intertwined; therefore, we'll occasionally look at the way in which the body is posed in relation to the light.

Even before I pose the feet, I decide how I'd like the subject's face to be turned. I usually have the face turned toward the light. When posing a male subject, I tend to turn the body toward the light as well.

"Masculine" and "Feminine" Poses

The rules of posing have been in place for centuries. There are certain strategies thought to best showcase male characteristics and others thought to suit feminine qualities. Of course, some rules are meant to be broken, and your female client may look great in a masculine pose. Always consider the mood you wish to establish in the portrait when selecting a pose for the photograph.

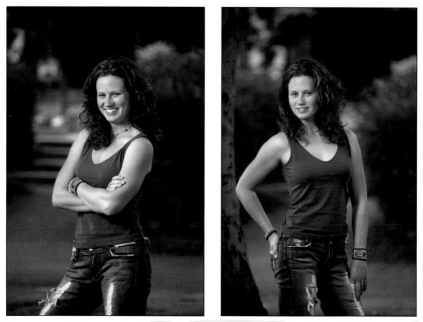

Many women look great in the masculine or basic pose (left), in which the body and face are both turned toward the light source. The feminine pose (right) plays up the S-shaped curve that heightens the undulating lines of the female form. The body is turned away from the light and the face is turned toward the light.

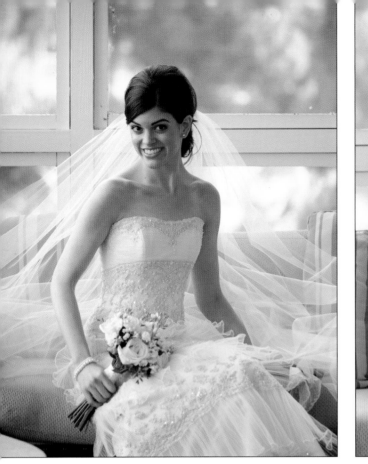

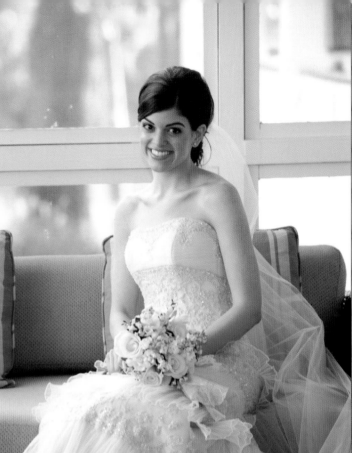

Above—Feminine and masculine posing applies to seated poses also. In the left photo, the bride is in the feminine pose, with her body angled away from the light and her face turned back toward it. In the right-hand image, she is shown in the masculine pose, with her face and body turned toward the light. **Right**—When crossing a seated subject's ankles, I typically have her cross the front leg over the back leg so that the sole of the foot doesn't show.

The "masculine" or "basic" pose is shown in the image on the right. In this pose, the back foot is angled toward the light. The subject's hips and shoulders are turned toward the light. Finally, the face is turned toward the light, and the top of the head is slightly tipped toward the light. In this pose, the body takes on a C shape. Therefore, the masculine pose is sometimes called the C pose.

When posing a woman, I typically turn her body away from the light. Her back foot is positioned to point away from the light at about a 45 degree angle, and the front foot is turned more toward the camera. With her feet in this position, her hips will be angled away from the camera, and I can turn her shoulders back toward the camera and turn her face more toward the light, with her head tilted slightly toward the light. This puts the two eyes on different levels, rather than parallel to the ground.

I am trying to achieve a slight S curve to the body. A very pretty and feminine shape. For the most part, women look good great in both the S and C pose. However, men usually look best in the C pose.

The feminine and masculine (basic) posing applies to sitting poses, also. The beautiful bride on the left is in the feminine pose. Her body is turned

away from the light, and her face is turned back into the light. On the right, her body and face are turned into the light.

No matter the basic pose, some other basic rules apply. Though you may have some success in posing a very slim person with their body square to the camera, more flattering images are usually created be positioning the body at an angle to the camera. Photographing a subject straight on can cause them to appear larger. Posing the hands and feet to point directly at the camera can also make those features appear distorted. We'll cover additional *dos* and *don'ts* of posing throughout this book.

In the masculine pose, or C-shaped pose, the subject's body and face are turned toward the light source.

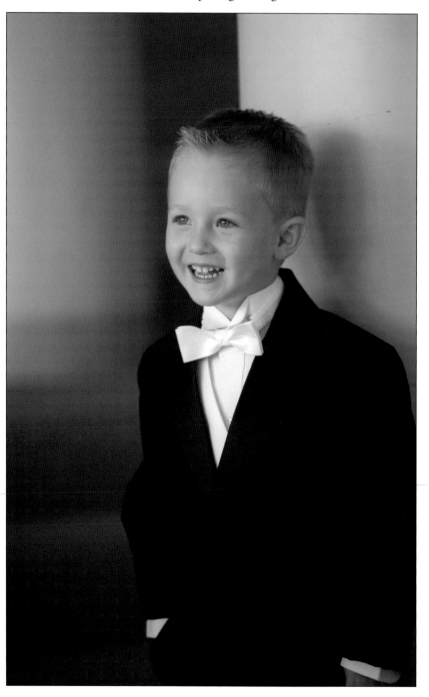

CHAPTER TWO

Expression and Head Positions

With a clear understanding of the basics of posing, we'll look at using some refinements that will help you to show every subject at his or her best.

Expression

The face is the soul of the portrait. One of my first teachers, Donald Jack, always said, "Expression sells photographs," and he is right. Some of my best sales of portraiture were not the best posed images, but photos in which mom loved the expression.

There's one thing that's certain: Though a great expression can sell a photo, if we work to achieve the best pose we can *and* get a great expression, we've got our clients' business.

The Tilt

In the previous chapter, we discussed the desire to form dynamic lines across the body. This preference carries through to the head. When posing your subject, strive to tilt the head, usually at a different angle than the shoulders. This will help to ensure that the client's eyes are not horizontal to the ground and will ensure a more interesting, dynamic feel.

There are three basic views of the face that we will work with: the full face (left), two-thirds view (center), and the profile (right).

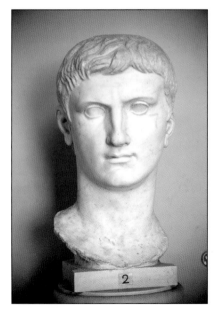 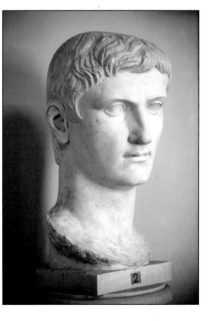 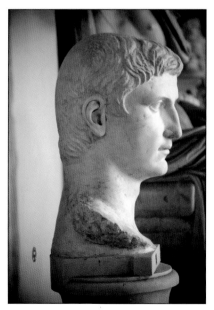

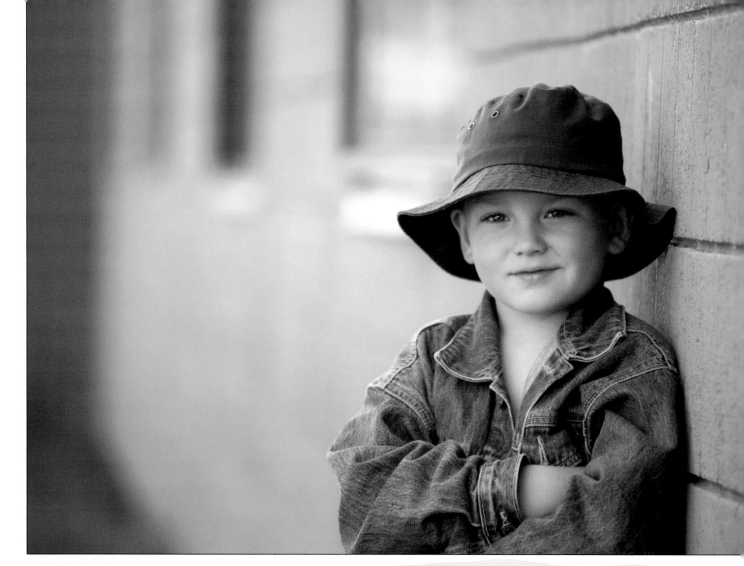

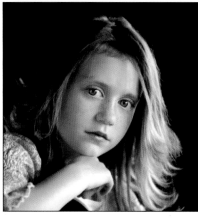

Above—The full-face view works best in children's portraits or in images of subjects with especially thin faces, as it visually widens the face. **Left**—This little girl's face is in a two-thirds view. If you were to draw an imaginary line down the middle of her face, you would notice the left side of her face (on the right side of the photo) is narrower than her right side (left side of the photo). Also notice that the edge of eye is contained within the line of her face. In this pose, the face can be photographed from either direction.

Full Face View

Also called a straight-on or head-on position, this view shows both sides of the subject's face equally. In this head pose, the subject looks directly at the camera. Be careful when instructing subjects to strike this pose. With some face shapes, this can make the face look wider. Therefore, the pose seems to best suit people with thin faces, or young kids.

Two-Thirds View

The two-thirds view of the face is the most often-used head position in portraiture. In this pose, the head is between profile and full face position. Both sides of the face are visible, but the camera side is shown more fully, with the far side of the face appearing more narrow. The pose is flattering to most subjects. The pose beautifully presents the planes of the

full FACE =
children & Thin
FACES

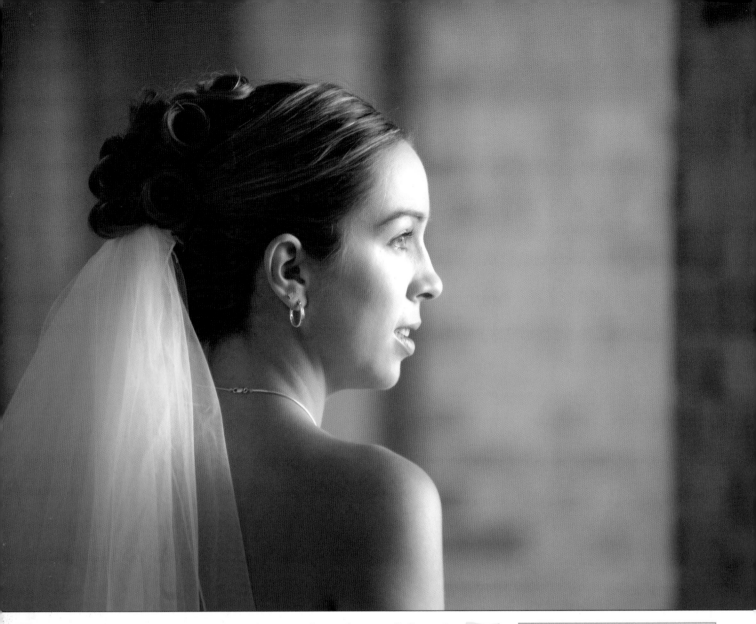

face to the camera, creating a sense of roundness and dimension. Note that the far eye is contained within the line of the subject's face.

In the two-thirds view, the face can be photographed from either direction.

Profile View

A profile view shows just half of the subject's face. I have heard some photographers say you should be able to see the eyelashes of the subject's hidden eye when he or she is positioned in the profile view. That may work with people who have long eyelashes, but some subjects' eyes are a bit deep set, and to see their lashes, you would have to turn the face back toward the camera too far, negating the profile appearance. Some photographers retouch their profile images to remove any eyelashes visible on the far side of the subject's face.

Too Far

In the image below, the face is turned too far away to be a two-thirds view and not far away enough away to be a profile. The nose sticks out past the cheek, and only part of the eye and a small part of the far cheek are visible. For some subjects, this pose can cause the face to appear distorted;

other subjects may look okay. These are guidelines, not hard-and-fast rules. What matters most is making your subject look great.

The Eyes

Many times when a subject looks away, their eyes turn farther than their face. This causes too much of the white part of the eye to show. The life of the eyes are in the iris, the colored area of the eye.

When posing people, I tell them what I want them to do and what they can expect. I tell them that when most people look away, they look farther with their eyes than with their face, and I demonstrate with my eyes. I tell them I would like them to look where their nose points, or to center their eyes in their eye sockets. Sometimes I give them something to look at, such as a tree or a spot on a wall, and then I watch their eyes.

Facing page—The profile of this lovely bride shows only half of her face. **Below**—In the top image, the girl's eyes are cut too far. The bottom image is better, but there is still room for improvement. **Right**—The final image in the series shows a big improvement in the position of the eyes.

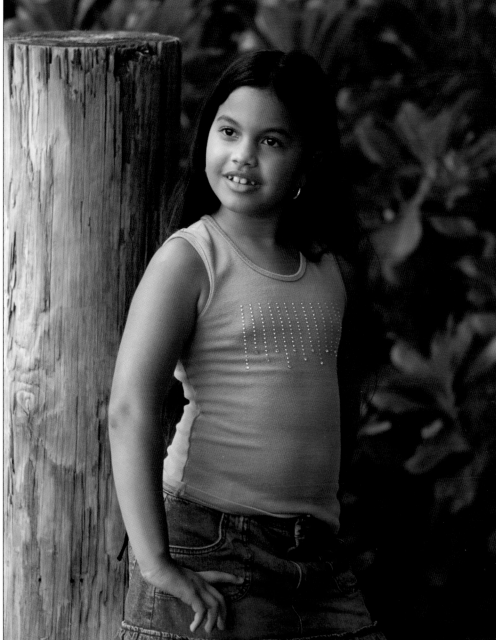

Portrait Lengths

Full Length

Full-length portraits make up a small portion of the various poses most photographers rely on in a client's session. Of course, some scenarios call for full-length shots. Brides, for instance, will want a photographic record of their gown and the way they looked on their special day. Models, too, are often prime candidates for full-length posing when showing off a designer outfit—or their physique. For the average client, three-quarter or head-and-shoulders poses are more commonly used.

Posing full-length portraits is more challenging than posing the client in other views. It is important to realize that the more of the body that appears in the image, the more areas of the body there will be to finesse and flatter. Of course, when more of the body shows in the image, the likelihood that a client will take issue with some aspect of their appearance increases as well.

The subject shown in the image on the facing page placed her weight on her back (right) foot; this caused her right shoulder to drop. Her body was turned slightly away from the light, and her face was turned toward the light, with her head tilted slightly toward her higher shoulder. The eye moves from her face and across the triangle formed by her arms. The flowers are held low and cover some of the expanse of the gown, visually slimming the bride's midsection. With her left hand posed delicately and gracefully, we have a lovely line that extends down the arm and to the tip of the finger, then continues to the bottom of the gown, allowing us to take in the detail in the fabric.

Three-Quarter Length

In the three-quarter length view, the subject's head and torso are fully visible. The bottom of the frame usually hits the subject below the waist—often at mid-thigh or mid-calf.

When posing your subject and framing the portrait, you should be sure that the frame of the image will not intersect the person at the elbow(s) or knee(s). When an image is composed this way, there seems to be an implication that the limbs are missing, and this can cause the viewer to feel uncomfortable.

Facing page—Full-length portraits are ideal for showing the details of a bride's gown. In general portraiture, this portrait length is less popular than three-quarter-length or head-and-shoulders poses.

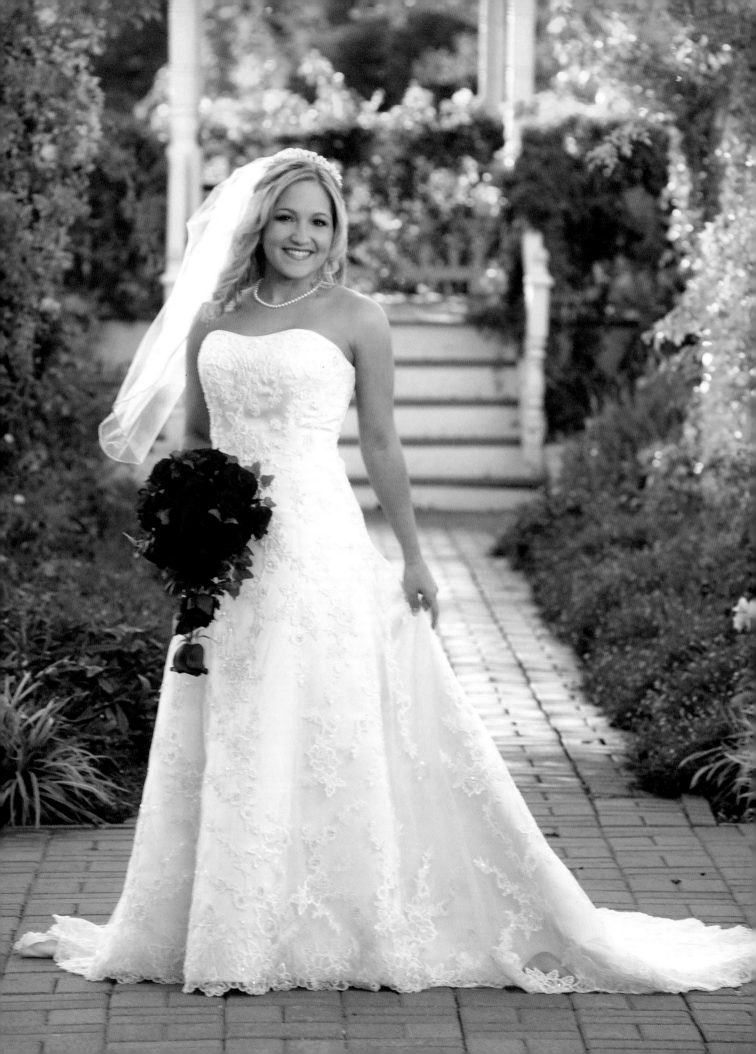

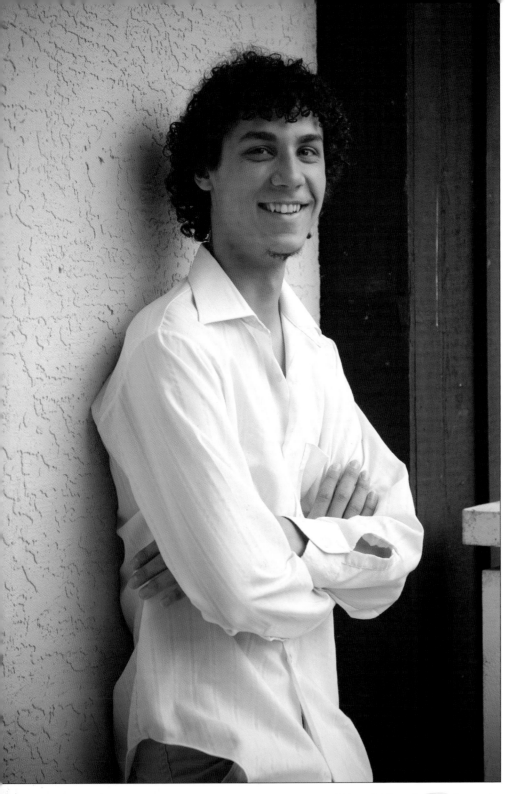

This casual pose perfectly suits the relaxed mood of the image.

The above image shows the subject in a relaxed, casual pose that suits the location and the subject's attire. His body is turned slightly away from the camera, with his head turned back toward the camera. We can see both hands, and there is nice separation between the fingers. The camera angle allowed the subject's head to be positioned in the upper third of the frame, which was an appropriate perspective for this pose. We'll touch more on the subject of camera angle in chapter 13.

Head and Shoulders

In a head and shoulders pose, the subject is shown from an area above the head to some point below the waist. This portrait length is often used for business portraits and school photographs, as the face tends to be the most prominent area of the portrait. Many such images are created in the vertical image format (with the narrower aspect of the frame horizontal to the ground); however, such images created in the landscape format (with the longest aspect of the image horizontal to the ground) can be effective—particularly when the background adds something to the image.

In the image below, the subject's body is presented in a more masculine pose, with the head and body facing in the same direction, and the head tilted slightly toward the camera. The fingers are tightly closed around the hand weight, but the pose serves a purpose. Note that there's an imaginary diagonal line that runs between her face and the weight in her raised hand. This keeps our focus on the subject's face.

This head-and-shoulders pose is full of energy and attitude—perfect for this subject and the background.

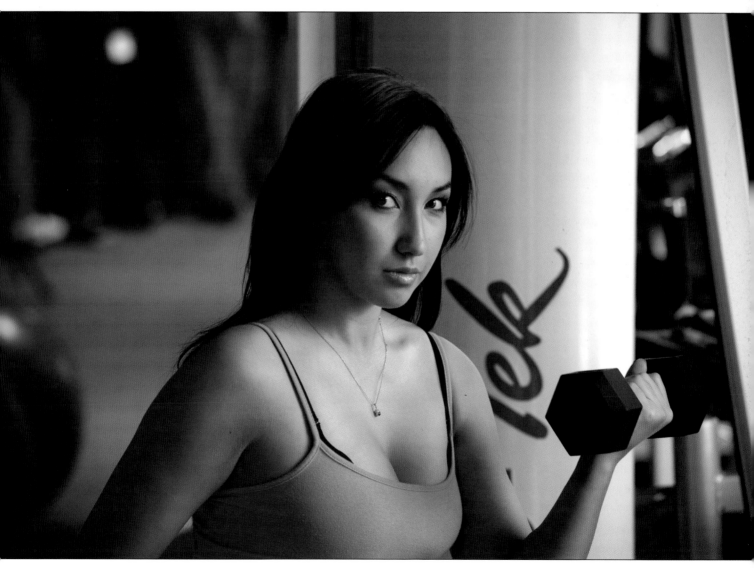

Posture and Presentation

The Best View

Earlier in the book, you read that full-face views of your subject will tend to visually widen the face. You learned that most people typically look best when their face is at a slight angle to the camera and that such positions allow the highlights and shadows that strike the client to shape the face and create a feeling of dimension in the image. Not surprisingly, the same guidelines hold true in flattering the length of the body.

Look at the images on the facing page and note the way a few simple changes to the subject's positioning and posture improved her appearance. In the top-left portrait, the subject's body is turned almost straight to the camera. The presentation makes her look wider than she really is. This model is not a large woman; she has a very nice figure. However, if you are not careful, you can make a small person look big—and needless to say, this can hurt your portrait sales.

Posing and Lighting

Posing and lighting work hand in hand to sculpt your subject and create the feeling of a third dimension in your images. In the top-left photo, the woman's positioning in relation to the light creates a less than flattering lighting effect. Her face is turned too far away from the main light, and there is not enough fill light to soften the harsh shadows on the right side of her face (opposite the camera). In the top-right image, I turned her face more toward the main light and turned up the kicker light. Without the kicker light, her hair would have blended in with the background.

In the bottom-left image, the woman's body is turned farther from the main light. See how much smaller her body looks. In this image, as in the second photo, the kicker light provides rim lighting, which separates the subject from the background.

To create the final image, I used a reflector to fill in the shadow side of the face. If I was to redo this image, I would have had her bring her right elbow forward a little so we could see it.

The third and fourth images are equally attractive, but each has a unique mood. Some viewers will like one image better than the other. The look you prefer is your choice. You are the artist.

> **Kicker Light**
> A kicker light is usually positioned opposite the main light. It can act as a hair light or to help visually seperate the subject from the background.

Facing page—With a modeling light, you can gauge the effects of using a reflector to fill in the shadow side of your subject's face. The main light was a 4x3-foot softbox. It was turned horizontally and raised so that the bottom of the softbox was about level with the bottom of her sleeve. This kept the light from burning up (overlighting) the subject's arm.

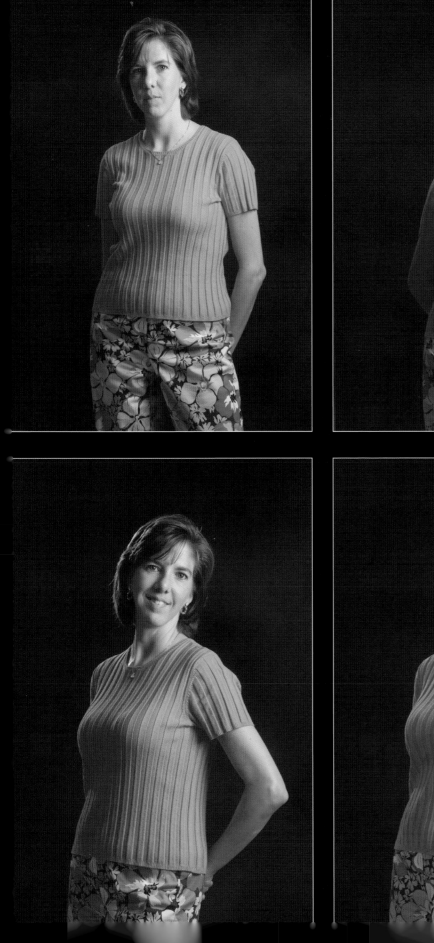
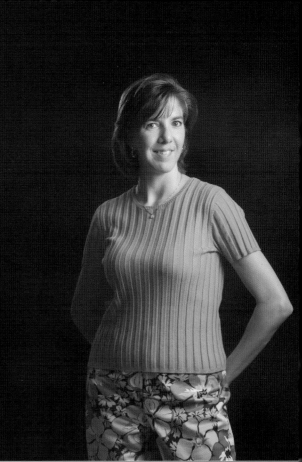
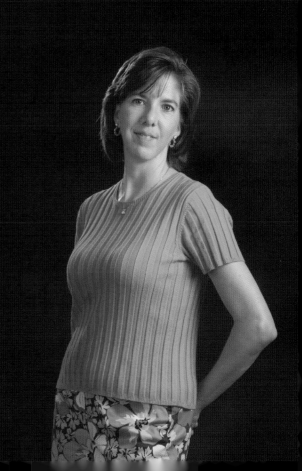

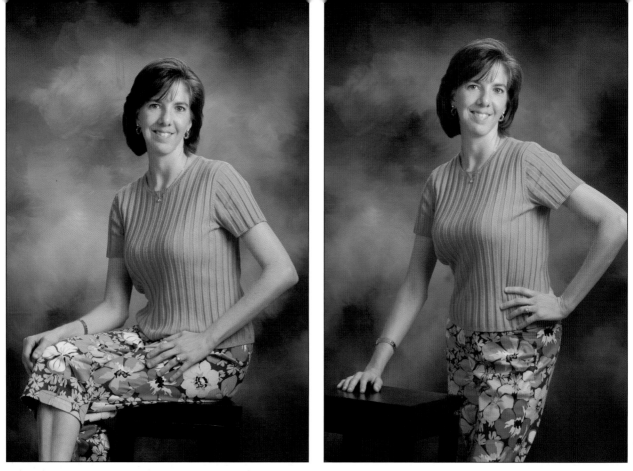

In these images, the woman's body was angled away from the light with her face turned back toward the main light. The head is tipped slightly toward the camera, and, in combination with the position of the shoulders and hips, a graceful S curve is evident. We can easily move from a seated pose to a standing one in which the posing stool serves as a support. Though this woman looks lovely in a seated pose, larger subjects may look better standing—especially in images in which there is only one subject. In group portraits, the apparent size of the body can be reduced by using other portrait subjects to partially conceal an area of the larger person's body.

Another potential problem in posing subjects is in seating them for a portrait in which the area below the waist will appear in the frame. In the image on the left, the subject is sitting flat on the small table. One of the things I could have done to improve the subject's appearance would be to not let her sit flat, but to let her feet touch the floor so her legs and body were not at a right angle. As seen in the image above, you can also use a stool or chair as a posing support. With the subject's right hand resting upon the seat, a nice diagonal was created that leads the viewer's eye to the focal point of the portrait—the woman's lovely face.

In the series of images shown in this chapter, you will note that the woman's arms, in every pose, are held in such a way so as to create dynamic lines and to allow space between the arms and torso. Creating this separation between the arms and torso always flatters the subject; conversely, posing the subject with his or her arms pressed to their sides tends to visually widen the upper body.

To create the most flattering possible presentation of the subject, we can finesse a pose that a subject might fall into naturally to show the client's figure to better effect. Look at the images below. In the photo on the left, the light and expression on the subject's face are lovely. Her torso

is at a slight angle to the camera, and her face is turned more toward the camera and the main light. There are a series of dynamic lines, all forming leading lines that guide your eye through the portrait. There is space between the clients arms and upper body. This helps to create a slender view of the woman's figure. The image is attractive, but it can be improved upon.

So, what is the shortcoming of the left-hand portrait? It's the position of the woman's right arm. In resting her right hand over her left hand, her right arm seems passively posed and almost appears to "drop off." The portrait on the right shows the simple fix. By moving her right hand to her waist, we're created space that narrows the apparent size of the subject's body. Repositioning her arm in this way created another benefit: in the right-hand image, the subject's shoulder line appears stronger and less passive. There is now a strong base (foundation) to support the head pose. The right-hand portrait, as a result, has a different mood, and the subject seems to exude more personality and energy.

In the images below, we have a relatively passive presentation (left) and a stronger one (right). The second image was the result of making some simple refinements to the starting pose.

Hands and Arms

Posing Hands

You've heard it said that you can tell a lot about a person by looking at their hands. Likewise, you can tell a lot about the portrait subject by looking at his or her hands. Fortunately or unfortunately, you can also gauge the photographer's skill at posing by considering the hand pose of the subject.

When posing the client, you should take care to avoid pointing the hands straight on to the camera to prevent them from appearing distorted. The hands are best viewed at an angle to the camera, and, when possible, care should be taken to photograph the side of the hand, which gracefully continues the line of the arm when the hand is bent upward at the wrist.

Avoid having the client curl their fingers into a fist. Rather, present the hand with the fingers somewhat outstretched and with a slight space between all of the fingers.

Notice the effect that the hand pose has on the overall mood of the portrait. In the image on the left, the hands are tucked under her arms. The image has a closed off look. In the center image, the subject's left hand appears attractive. The wrist is bent upward, there is space between the fingers, and the hand has a graceful appearance. However, with the woman's right hand hidden from view, the pose seems unfinished. In the final image, the woman's hands seem to show warmth and grace and add to the pleasant mood of the image.

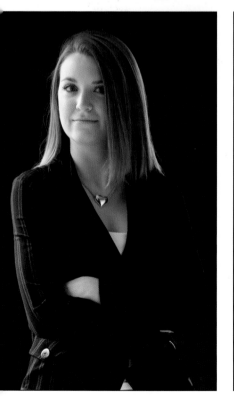 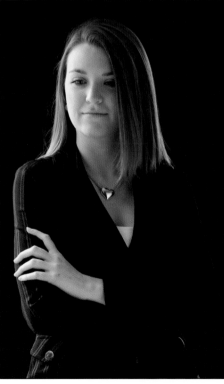 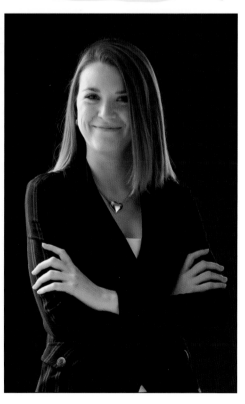

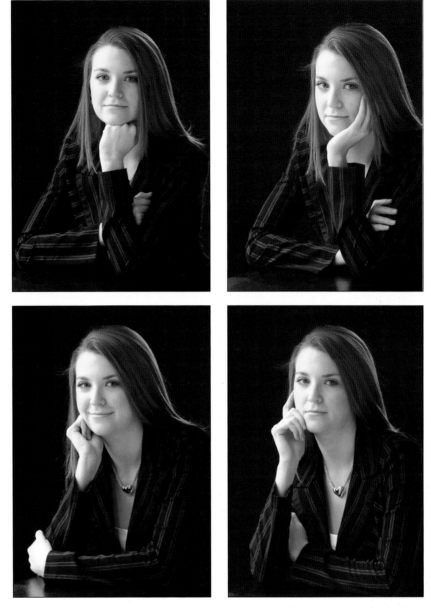

In this image series, we start with the hand in an undesirable position. The back of the hand is straight on to the camera and, with the fingers curled inward, the hand looks like a fist. The second image shows an improved hand position, but the third and forth images are more pleasing still.

The above images show several ways in which the subject's hand can be posed resting on her face. In the first image, the back of the hand shows, creating a fist-like appearance. The second image is better, but her hand obscures too much of her face. In the third image, the subject's right hand was placed on her far cheek, and we have a full view of the left side of her face. Her left hand is wrapped around her elbow. To improve the pose, the woman extended her left index finger; this draws the viewer's gaze to her face or, more specifically, to her eyes. We see the edge of the hand, and if we follow the lines of her arms with our gaze, we can see that the pose

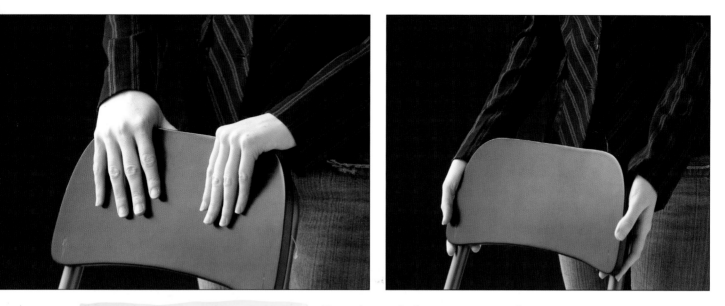

helps to lead our eyes through the frame. Since the eye is drawn to areas of sharp contrast, we hid a portion of her left hand from view. It does not appear "missing"; rather, with less of her skin showing, the prominence of the hand has been visually diminished.

The photos above illustrate two more hand posing options. The image on the left shows too much of the back of the hands. The right-hand photo presents a more desirable, graceful view.

In general, women's hands should appear graceful, and men's hands are posed to show strength. When posing men's hands, it is common to slightly curl the fingers. Be careful to ensure that the fingers are not tightly curled into the palm; again, in this position, the hands look too much like fists. In posing men's hands, it is also important to show the side of the hand rather than the back of the hand, as the more streamlined view is more attractive.

Posing the Arms

The positioning of the arms can help to lead the viewer's gaze to the portrait subject's face. When creating a pose, it is often desirable to create a triangular form. If you look at the series of images shown on the previous page, you will see these concepts at work. The arms form diagonals that create a triangular shape, and those lines lead the viewer to the focal point of the image—the woman's face.

Earlier in the book, we discussed Ralph Romaguera's "twosey" law. It's a concept that's integral to posing your clients and is worth reiterating: any body part that a person has two of should be positioned at different levels.

When posing the arms, keep in mind that they should not be held tightly against the body, as this will flatten the arms and seem to widen the

This image pair shows two views of the woman's hands. In the top photo, there is a slight space between the fingers; this creates separation, providing a defined view of the hand. Unfortunately, the angle of the hands to the camera makes the hands appear too prominent. Posing the hands as if the woman was pulling the chair out, with her hands on the sides of the chair back, provides a more elegant, graceful view.

arms and torso. Even when the subject's arms are folded across their chest, ask them to hold them very slightly away from their body (also, be sure the hands do not tightly grip the arms, as this will distort the arms).

When a subject has a good figure, you want to show it off by showing the waistline. This is accomplished by having space between the arm and the waist (the subject's right arm in the left-hand images). I did not like the way her left arm was positioned in the the top-left image. The bottom-left image shows a better presentation of her left arm. Note the position of her right arm in the bottom-left portrait. The pose deemphasizes the waist area and can be useful for posing larger subjects.

In the upper-right-hand photo, the top of the subject's hands are pointing straigt toward the camera. This shortens the perceived length of the arms. Note that her shoulders drop almost straight down. In the bottom-

Always take a moment to finesse a pose to make sure your subject looks her best. Here, you can see the improvements in the refined poses (bottom row) over the starting poses (top row).

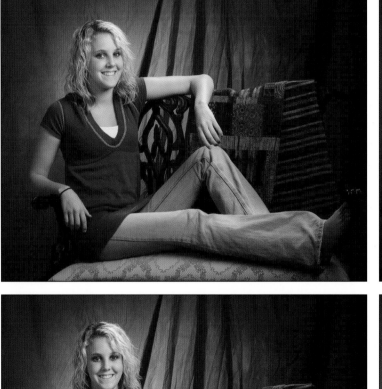

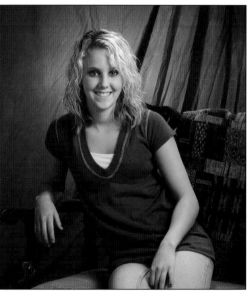

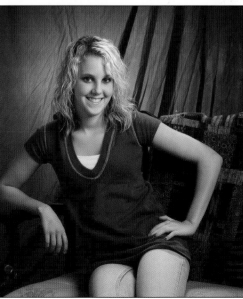

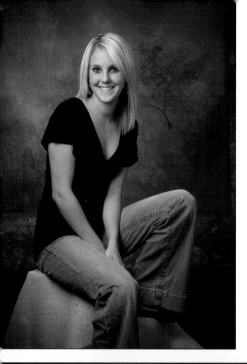

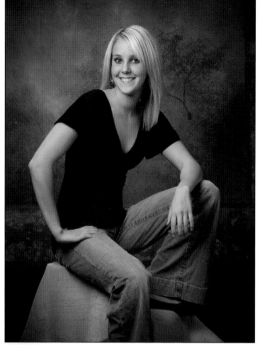

This trio of images shows the progression from a pose the subject naturally assumed (top left), to one she assumed with a few directives. The bottom image shows the refined pose. With her spine straightened, the image has more energy and polish. The pose is still casual, however. Sometimes holding the body in a position that feels slightly exaggerated or unnatural will produce very natural results.

right photo, the subject's arms appear to be in a more natural position but were actually posed. Posing doesn't need to look "posed"; it just needs to look better. The subject's shoulders were positioned square to the camera. Though this is not ideal, it looks okay in this case.

As you read through this book, look at the various arm poses I've used for men, women, and children. Note the way they contribute to the mood of the portrait and how they aid in creating a composition that leads the viewer to the subject's face. You might consider re-creating some of the poses shown in this book with some of your own subjects. Also, magazines, classic portraits painted by the old masters, and even catalogs can be a great resource when learning how to best present the body. You can create an idea file to expand your posing repertoire, or you might present a collection of images showing posing options to your clients. Some clients may enjoy offering their input—and anything you can do to build rapport with your client will help to build their confidence and comfort.

Above, we have a series of images in which the subject is posed in a comfortable seated position. The first image shows the pose the client fell

into when she sat down. Many photographers like to photograph their subjects "as they are." I believe that one of my responsibilities as a photographer is to make the subject look their best. We need to look at each individual client and pose them in a way that flatters their form. The first, "unposed" portrait does not make the most of the client's figure. Her arms are held close to her body, with her hands together. The pose in the second image is a little better, but her left arm is pointing toward the camera, resulting in a distorted, foreshortened appearance. Also, her posture could be improved upon: her back has a convex curve. We have addressed these issues to create the third image. Note the huge difference in the woman's appearance once her back was straightened and her arm was pulled in toward her body. Taking the time to finesse the pose can make a good portrait a great one.

Let's look at the image pair below. Though the first image may appear acceptable at first, a closer look will reveal some shortcomings. The legs are pointed at the camera, as is the subject's right arm and hand. With her weight on her left hand, her left shoulder was pushed up, making the shoulder appear too horizontal to the top and bottom of the image frame. What a difference a few changes make! The image on the right shows the subject in a well-crafted pose. The subject's body was turned slightly away from the camera, with her face turned back toward the light. Though she appears to be resting on her hand, her weight is on her left hip, and her hand is merely resting on the ground. This allows us to show her shoulders in a desirable, more dynamic position. Finally, her legs were angled away from the camera, with the full length of the top leg visible. This creates a beautiful line and beautifully renders the subject's figure.

Though the left image seems nice enough at first glance, it breaks a number of posing "rules." The image on the right is far better. Note how beautifully the subject's figure is rendered.

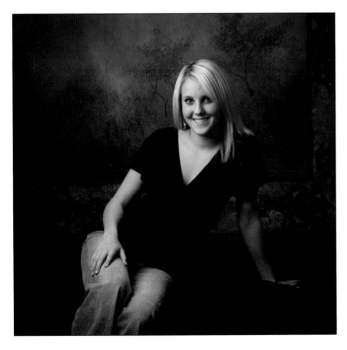
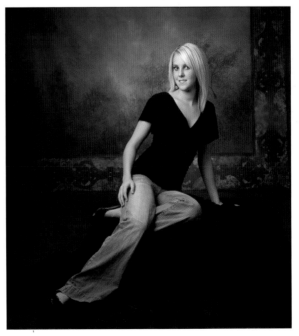

Composition

The Basics

Composition refers to the position and prominence of all of the elements in an image—the people, the clothing, the props, and the background. We've touched on the topic in other chapters. For instance, we've talked about dynamic lines and the way that posing the body in a particular way can create leading lines that draw the viewer's gaze toward the focal point of the image. Triangular shapes imply strength and stability, and we've already noted the way in which the diagonal lines of the arms, when posed away from the body, direct the viewer's gaze to the subject. We've also discussed the C- and S-shaped poses that beautifully render the human form. These shapes are also appealing in other areas of the image. A winding road with an S curve, for instance, can guide the viewer's eyes across the image.

The Rule of Thirds

Before posing the body, you should consider your subject's placement in the overall scene. There's a simple guide used by photographers to ensure dynamic images—the Rule of Thirds.

To determine the best possible subject placement, try to picture an imaginary tic-tac-toe grid superimposed on your scene. The most effective placement for your subject will be at one of the power points—at one of the four places where the horizontal and vertical lines intersect.

So, how is the rule of thirds applied to portraiture? Well, in a head-and-shoulders portrait, the eyes, as the focal point of the image, should ideally rest on one of the grid's lines or at a power point. This means that in a three-quarter or full-length portrait, the face should be positioned at a dividing line or power point. In images captured in the portrait format (with the short side of the frame positioned horizontally), the subject's head should fall at about a third of the way from the top of the frame. In images captured in the landscape format (with the longest side of the image oriented horizontally), the eyes or face of a seated or standing subject should appear at a dividing line or power point. If the subject is reclining, he or she may be positioned at the bottom third of the frame, with his or her face or eyes positioned at one of the lower power points.

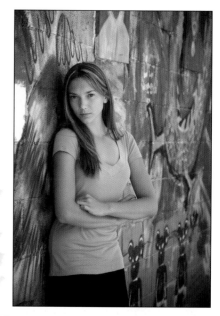

In composing an image, we must consider how all of the visual elements work together to capture the viewer's attention and draw it through the frame to focus on the subject. The Rule of Thirds is at work in this portrait and is, in part, responsible for creating visual interest.

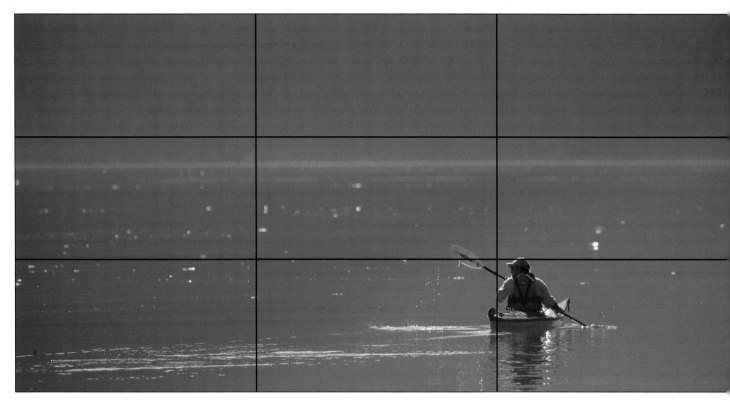

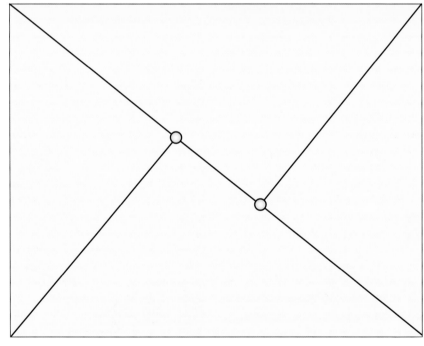

The Rule of Thirds (top) and Golden Mean (above) are two compositional guidelines that help you to ensure dynamic subject placement.

On a related note, it's a good idea to ensure that you do not allow the frame of your image to bisect a portrait subject's joints. It's best to crop an image at the middle of the upper arm or forearm, mid-thigh or mid-calf.

The Golden Mean

The Golden Mean is another compositional guideline used to determine ideal subject placement. To determine the Golden Mean for portrait- and landscape-format images, draw a straight line connecting the upper left and bottom right corners. Next, draw a line from the upper-right corner to the bisecting line, ensuring it is perpendicular to the bisecting line. Finally, draw a line from the lower-left corner to the bisecting line, again ensuring it is perpendicular to the bisecting line. The two points where the lines intersect are considered the power points. Though the recommended placement is similar to that obtained through the Rule of Thirds, the power points are slightly closer to the center of the image.

Direction

When the subject is placed at one of the power points dictated by the Golden Mean or Rule of Thirds, there will be slightly more room on one side of the subject. Compositionally speaking, it's best to have the subject "look into" the open space than to have his or her gaze directed in the opposite direction, toward the "short side" of the frame.

Leading Lines and Shapes

The position of the arms, legs, and other scenic elements can form lines that lead the viewer's gaze toward the subject, or, more specifically, to the focal point of the image (e.g., the face). In the images below and on the facing page, note that the line formed by the paddle and up through the woman's right arm draws the gaze from the entry point on the left side of the image to the woman's face. By "connecting the dots" in the photo below, the viewer's gaze moves easily from the paddle, to the face, down the woman's left side, and back up to her face, as the subject's left arm creates a strong line.

Leading lines can be straight or curvy. They can be comprised of natural elements, like a creek or winding road, or can be formed by the body. They can also combine to form shapes, like triangles, which are commonly used to build a "base" in the image.

In the following pages of this chapter, we'll look at the compositional elements of a few images so we can see how the pose and other image elements direct the gaze across the frame.

Note the triangular composition in this image. The triangle's "legs" create dynamic implied lines, and the base of the triangle lends a sense of stability.

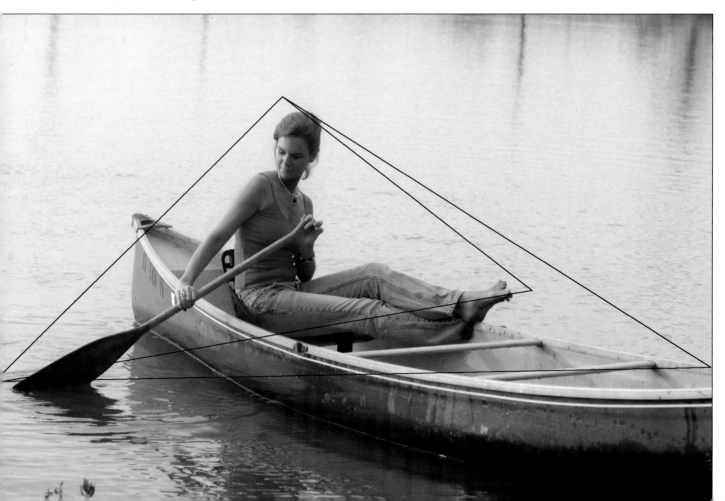

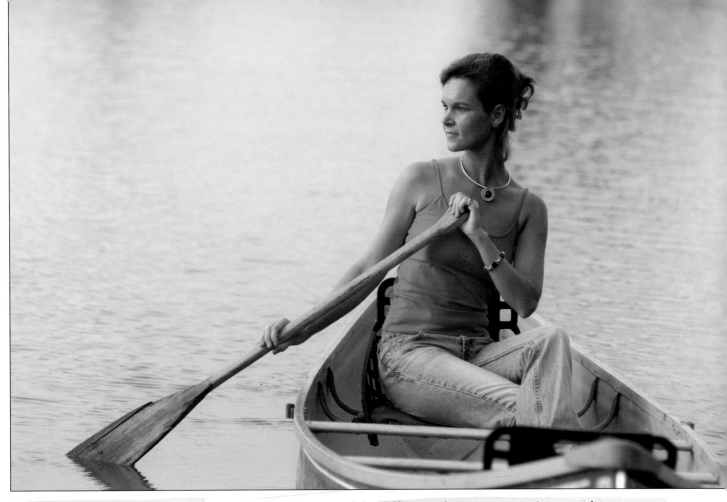

This pose creates a nice triangular form and strong leading lines. Note how the crossing of the woman's legs adds a comfortable and relaxed feeling in the image. Also, look at the subject's arms and hands. I had the woman hold the paddle as if she were really paddling the canoe, but I also made sure that her hands looked attractive from the camera and that she appeared comfortable.

I believe that one of the differences between a so-so image and a great portrait lies in the handling of the small details. Take the time to finesse every pose. Also, make sure you look at all four corners of the frame to ensure there are no distracting elements in the composition before pushing the shutter button. In this case, I raised the camera angle on these images so the shoreline would not cut through the center of the image.

Tension and Balance

Tension and balance are important compositional concepts. "Balance" is achieved when two subjects are of relatively equal prominence or strength in the image. "Tension" is achieved when there is visual contrast in the image—for instance, a close-up portrait in which there is an out-of-focus subject in the background who is rendered much smaller and less visually important in the frame. The tension can be relieved by making some small adjustments. For instance, in an image featuring a group of kids playing in the lower-right power point, a brightly colored hot-air balloon, though small in the frame, would also command attention. Keep in mind that tension can be used to draw the viewer's attention to a particular area of the image.

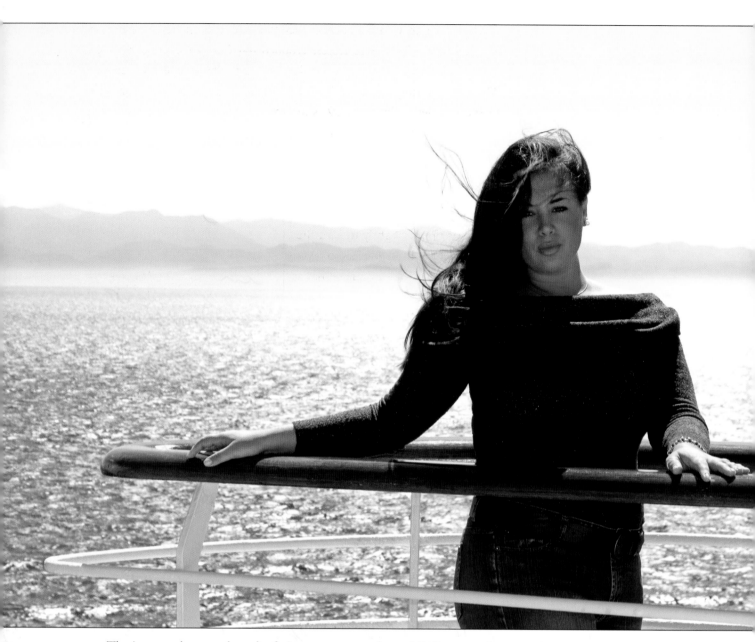

The images above and on the facing page were taken while I was teaching a photography class on a cruise ship. In the image above, I had the woman rest her hands on the railing, then slide her right hand farther from her body. By refining the pose in this way, the viewer's gaze is directed from the point of entry on the left side of the frame and to the subject's face. Her left arm is coming straight toward the camera, a position I do not usually like, but in this case, it seems to work. Her left arm seems to serve as a visual stopping point that keeps the viewer's focus on the subject. I had the woman turn her hips slightly away from the camera and kept her shoulders facing the camera to present a more slimming view of the hips. Note that this image, like the ones on the previous pages, has a triangular composition.

Here's a great application of the Rule of Thirds. The model's face is positioned approximately at the upper-right power point, and her outstretched arms rest on the lower third line.

On the right, we have another nice three-quarter length presentation of the woman. The more closely cropped framing of the image was appropriate, since the background did not add to the feel of the portrait. There are a variety of interesting lines and angles in the portrait, inherent in the wooden railing as well as in the bending of the subject's right arm. The subject placed her weight on her back foot, turned her body slightly away from the camera with her face turned toward me. Her head was tipped slightly toward the camera. The subject appears to be in a natural pose, and the image has a candid feel.

In the image below, the sweeping lines of the railing seem to envelop the subject. Her outstretched arms form a strong triangular base, her weight is on her back foot, and we have a nice bend in the front knee.

The leading lines in the railing guide the eye to the viewer and allow the subject to rest her arms, creating the desired triangular base.

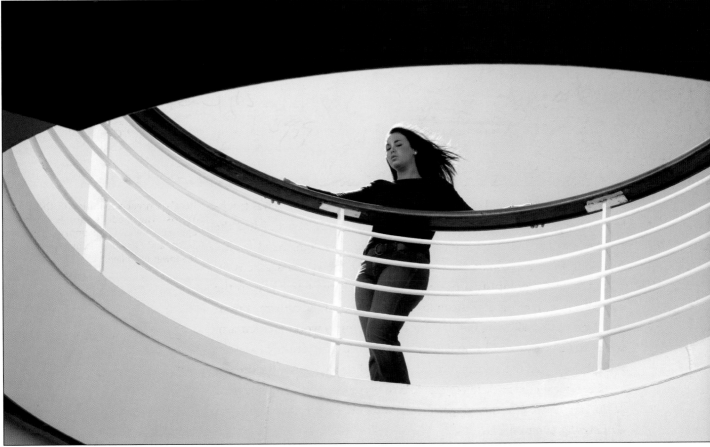

Posing Men

Facing page—Though this handsome subject had his weight on the wrong foot, one hand tucked in, and his right shoulder lower than his left, the image works. Making your subject look good should be your primary goal. **Below**—Though "nontraditional," poses featuring your subject engaged in an activity can be popular with your clients and can help you build bigger sales.

The Basics

When posing men, many of the same considerations are taken into account as when posing women. You will want to start with the base—the feet. You should typically have the subject put his weight on his back foot. This will drop his back shoulder slightly. You'll want to ensure that the subject is relaxed and as comfortable as possible. Be sure that the body language suits the subject and reinforces the mood of the portrait.

Don't overlook the possibility of using elements in a scene to help develop the pose.

Crossed-arm poses are often used with male subjects. When posing your subject in the manner, tell him to hold his arms very slightly in front of his chest. If his hands are resting on his biceps, ensure that he is not lightly gripping them; this will result in a distorted appearance.

When posing the male subject's hands, the general rules still apply: avoid showing the back of the hand and having the hands pointed directly at the camera. There should be a slight separation between the fingers. With men, it's a good idea to show strength in the hands, rather than grace. It is acceptable to have the man curl his fingers in gently toward his

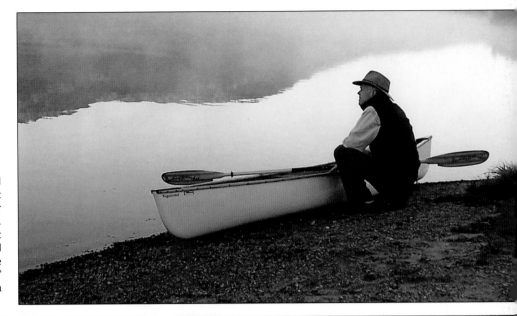

Right—The pose in this image is casual but appropriate for the scene. The subject seems contemplative, and with the somber tone of his surroundings, the image works. **Below**—I must admit, sometimes I'm not sure how to best pose a subject, so I will take a variety of images and choose the best of the bunch. Below are two "takes" from a single session. Each image has a different feel.

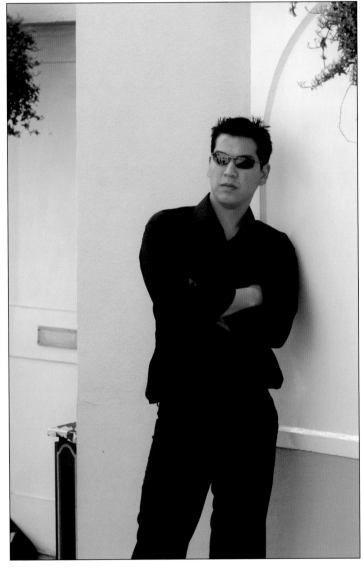

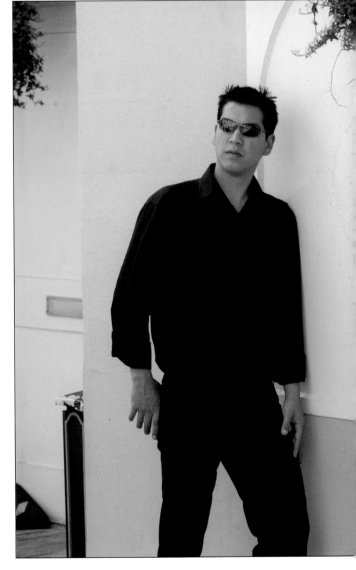

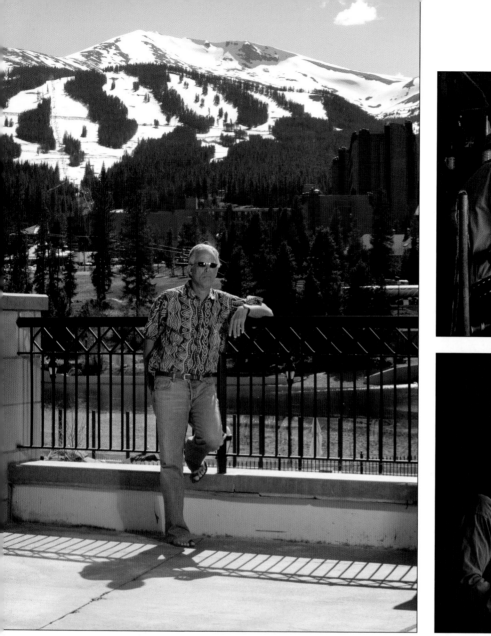

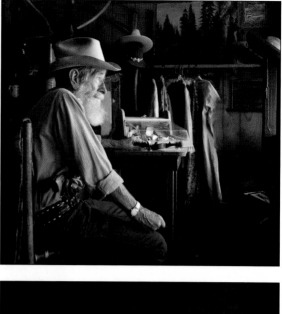

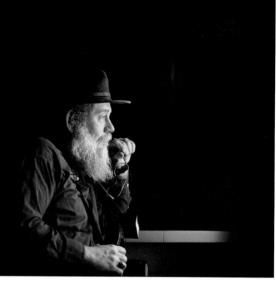

palm. Some photographers find that having the subject wrap his fingers around a pen cap can produce the desired look. Other ideas for posing the hands include hooking the thumb through a belt loop or over the top of a belt. Some photographers advocate slightly tucking the the thumb into the front pocket for a casual portrait look.

In the images at the top left and right of the page, the subject's environment is an important part of the image and helped to dictate the pose. In the outdoor portrait, the style of dress is casual, and the pose was designed to suit the scene. The subject's body is turned slightly away from the camera, his left shoulder is dropped slightly, and his left arm and leg form interesting angles.

The top-right image shows an elderly subject seated in his antique shop. Though his pose is somewhat rigid, it seems to suit the tone of the image. Note how the mood of the portrait changed with the subject and scene

The pose should relate to the background and locale. Casual settings and attire call for relaxed poses.

differently framed and the pose made more dynamic. The gentleman has a reflective look that suits the more pared-down surroundings.

Perhaps one of the most salable of men's portrait types are those that show them engaged in a favorite hobby or activity. In such images, you

Posing your subjects with a meaningful prop can lead to increased portrait sales.

must strike a balance between presenting the subject in a flattering manner with a presentation that makes sense to viewers.

This image at the bottom of the page was made during the same trip as the image shown on page 31. I chose a different camera angle, framed the image so that the subject's position was different, and snapped the shutter when the paddle was at a dynamic angle. Converting the color image to black & white using Photoshop and Nik Software filters helped the viewer to focus on the subject. The eye is drawn to area of sharp contrast. The tonal differences between the subject and the water and the left- and right-hand mountain keep the viewer's gaze of the subject.

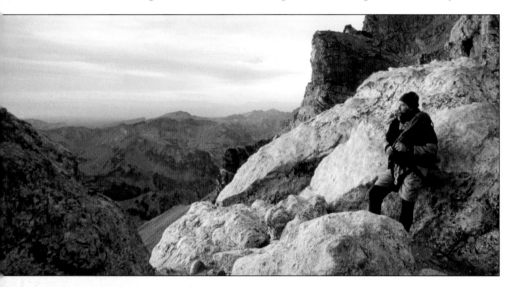

These are great environmental portraits. The pose makes sense and suits the scene.

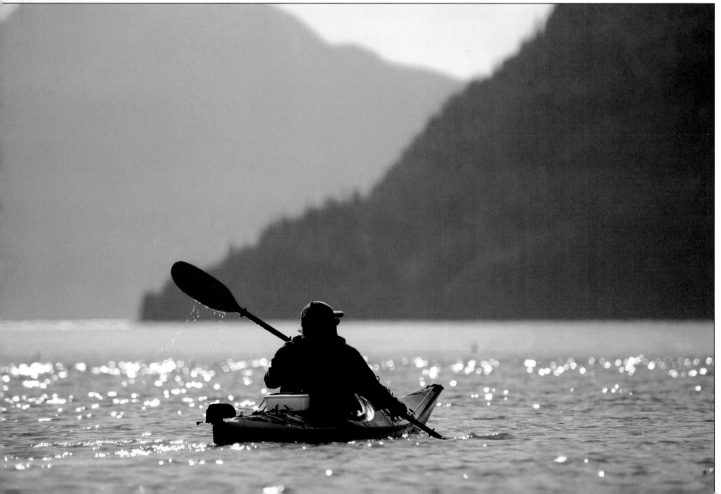

Here we have the same basic pose with a minor variation—the position of the camera and the arms. Though the differences between the images may seem subtle, the top image seems more natural and appealing.

The above image was made in all available light, and so I had to position the subject in a place where the overhead light would be blocked. This is, obviously, an environmental portrait that depicts a photographer with his camera. We can imagine that the photographer took a break from photographing after taking a long trek through the woods, and that a fellow photographer saw a

great opportunity to take a picture. There are two image variations shown. The only real difference between the top and bottom image is in the way the subject is holding his camera. In the smaller photo, the camera is too prominent for my tastes and detracts somewhat from the real subject of the photograph—the photographer. In the larger portrait, the camera is slung over the subject's shoulder. It is prominent enough to show the subject's hobby but does not overwhelm the image or distract the viewer's gaze from the subject and his relaxed pose. In my mind, the larger photograph is a better, more natural depiction of the subject and scene.

All of the elements in the image below come together to form a very nice outdoor portrait. I had the subject pose with his weight on his back foot. This caused his rear shoulder to drop. I had him turn his body away from the light source to put his shirt into shadow so the deep contrast of a pure-white shirt and a black vest wouldn't draw too much attention. I had the subject look up a bit to get light in his eyes. I selected a long focal length lens (200mm) to throw the background out of focus, rendering the windows in the upper-right area of the scene visually unimportant.

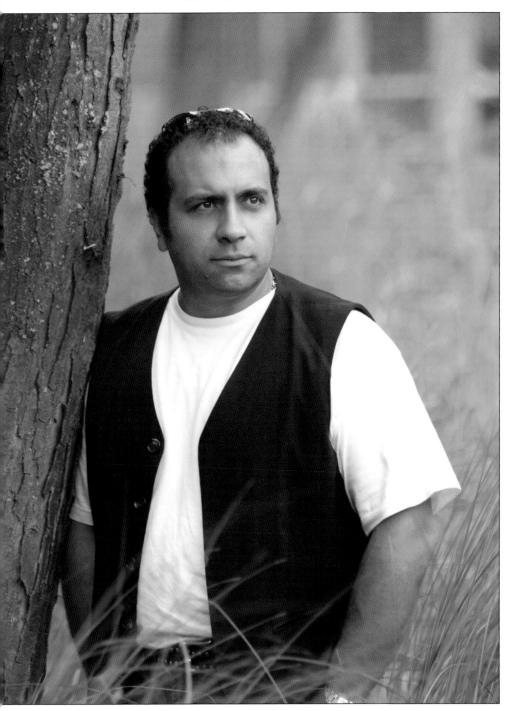

Here's a relaxed, masculine pose that looks as if it could be natural to the subject. A long lens was used to blur the background, visually diminishing the prominent white windows.

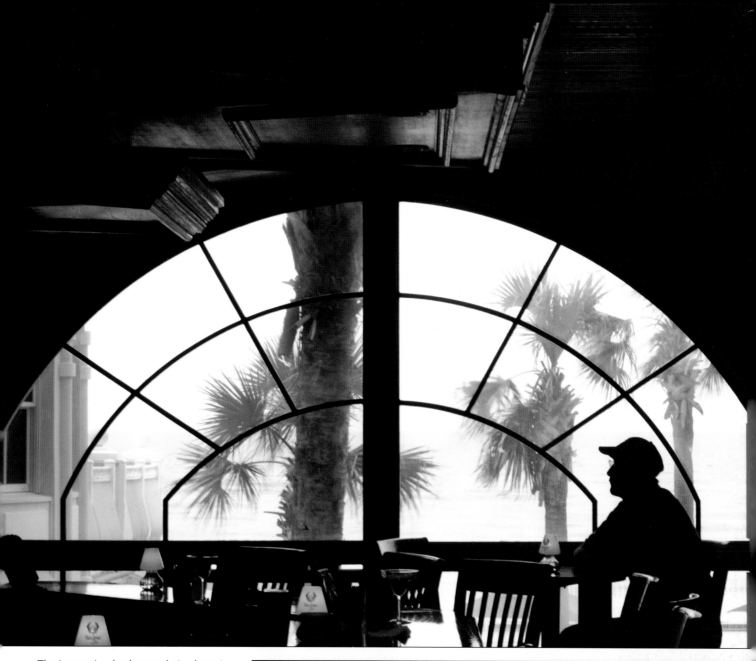

The interesting backgrounds in these images make them fun to look at. The pose in each image is simple. The lighting and the sense of place set the mood of the image and captivate the viewer. Note that when you're photographing a subject in silhouette, as in the above portrait, you should take care to show the face in profile so viewers can identify the subject. It's also important to provide space between the arms and torso, as we did here, to best show form. In a standing pose, the silhouetted subject's legs should be held slightly apart to show the person's form.

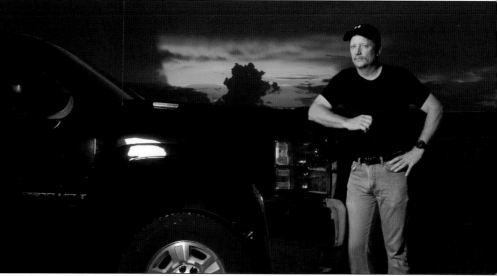

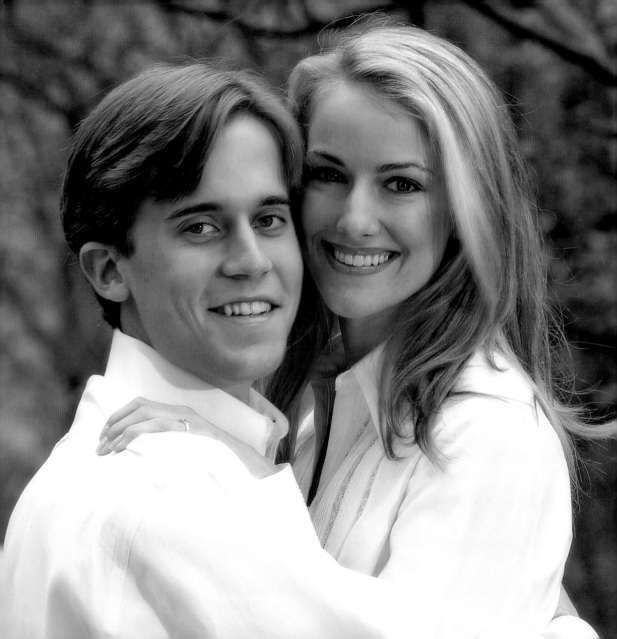

Posing Couples

The Basics

The same basic posing rules we've discussed to this point hold true when posing couples. Each person's weight should be on their back foot, the shoulders, arms, and legs should be presented at varying angles, and the edge of the hands, rather than the backs of the hands, should be shown to the camera.

When posing couples, it is important that each individual looks their best, and then the two should be positioned in such a way that they seem

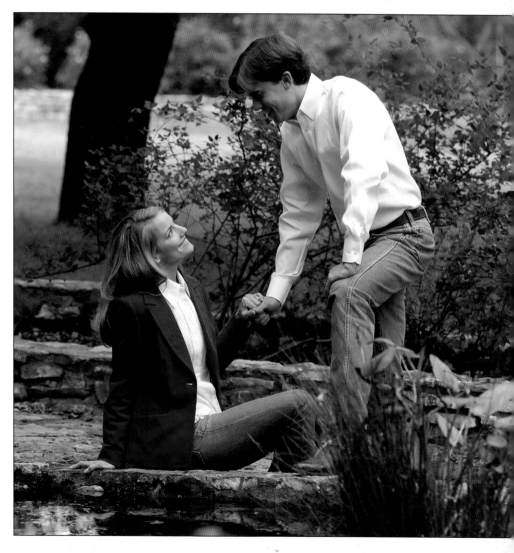

Having the couple wear coordinating clothing will lend a unified, harmonious feel in the image. Note the diagonals at play in the image on the facing page and the one shown on the right. The viewer's gaze flows easily from one face to the other, and back again.

to relate to one another. By angling the couple's faces toward one another, we can begin to build a storytelling image that speaks to the viewer about the unique bond the couple shares. Additionally, the image should be composed to ensure that the subjects' positioning leads the viewer's gaze to the focal points of the image—their faces.

In the images below, we have two completely different portrait looks. The couple is in the same location, but the focus of each portrait is different. In the left-hand portrait, each person looks great in their individual pose, but their bodies were brought together in a way that illustrates their close bond. The right-hand image has a different look; it is closely cropped, and the emotion between the couple is the focus. There is a strong implied diagonal line between the faces, and with the heads placed in the top and bottom thirds of the frame, near the power points, the image is dynamic and engaging. Converting the photo to black & white eliminated distractions, locking the viewer's gaze on the expressions.

In the images on the facing page, we have another couple photographed in an outdoor location. This couple, like the one previously discussed, was asked to come to their session wearing carefully coordinated clothing. This helps to prevent one subject gaining visual prominence over another and creates a cohesive look. In these standing poses, the height difference works to our advantage, as the heads are at differ-

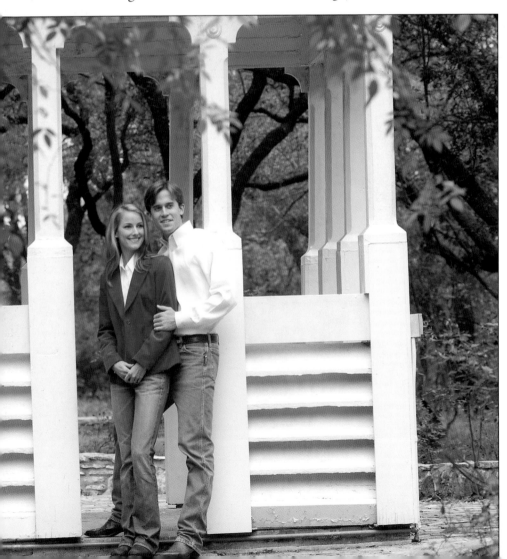

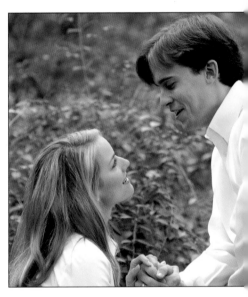

When posing groups of two or more people, we want to vary their head heights. This creates a rhythm to the image and adds visual interest.

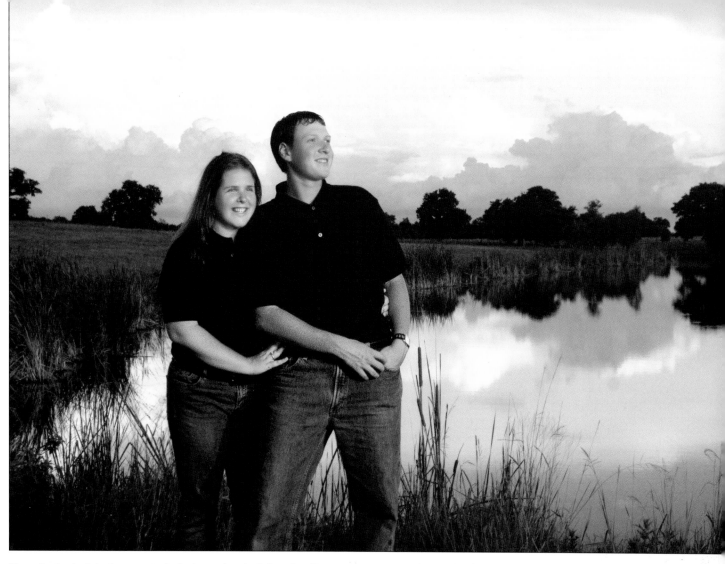

The cohesive look in these portraits is due in part to the matching clothing and the close proximity of the subjects' bodies.

ing heights, leading us to create an image with a more dynamic feel. In the top image, both subjects are posed similarly. We can see that the shoulders are at a dynamic angle, the man's and the woman's fingers are slightly splayed, and there is space between the legs to enhance each subject's form. The woman's chin rests on her beloved's shoulder, helping to illustrate the nature of their relationship. The matched posing of the couple's right arms further illustrates their unity.

In the bottom photo, we have a variation of the pose. The man's hands are tucked slightly into his pockets so that we can still see the tops of his hands. Though we might have had the woman pull her left elbow downward slightly in order to angle her hand so that the edge was visible, the overall pose looks natural and comfortable and is a success.

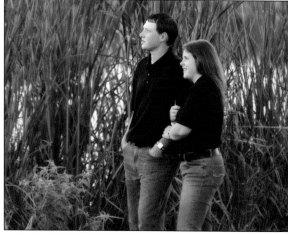

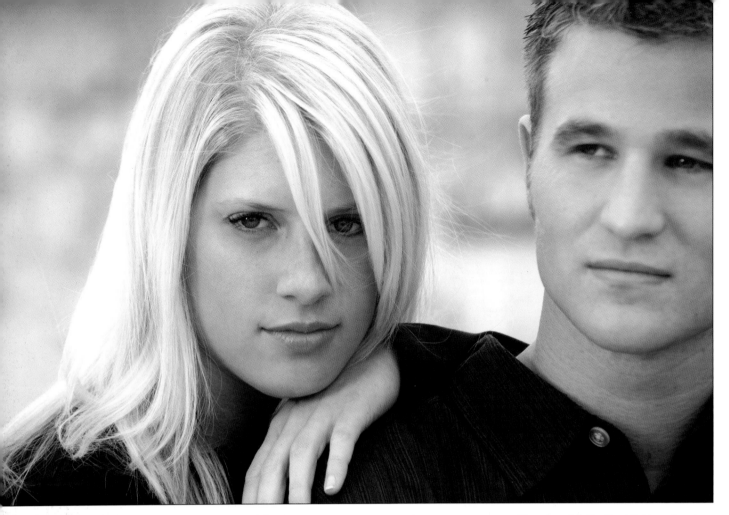

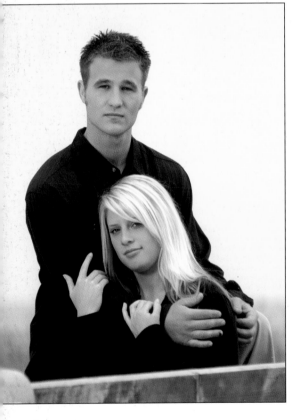

The images on these two pages have a fresh, clean, cutting-edge look that's popular with many clients. The close cropping in the image above puts the viewer's focus on the subjects' expressions. The woman's hand is angled away from the camera so as to prevent a distorted appearance. By keeping her hand by her face rather than more toward his, we avoid drawing the eye to an area of sharp contrast, which would detract from her face.

In the image on the left, the body of each subject is angled differently to the camera and the heads are at different levels and angles; his head is at the horizontal top-third line, and hers is near the bottom-third line.

Above and left—Establishing the close bond two people share is a primary goal when photographing couples. Their proximity speaks volumes, and in the image on the left, the couple mutually envelop one another. **Facing page**—Here we have a terrific, relaxed and casual environmental portrait. Each person looks good, and their body language illustrates the love they share. Each subject has their weight on their back foot, and though their bodies touch, there is a little space between them to create separation and show form.

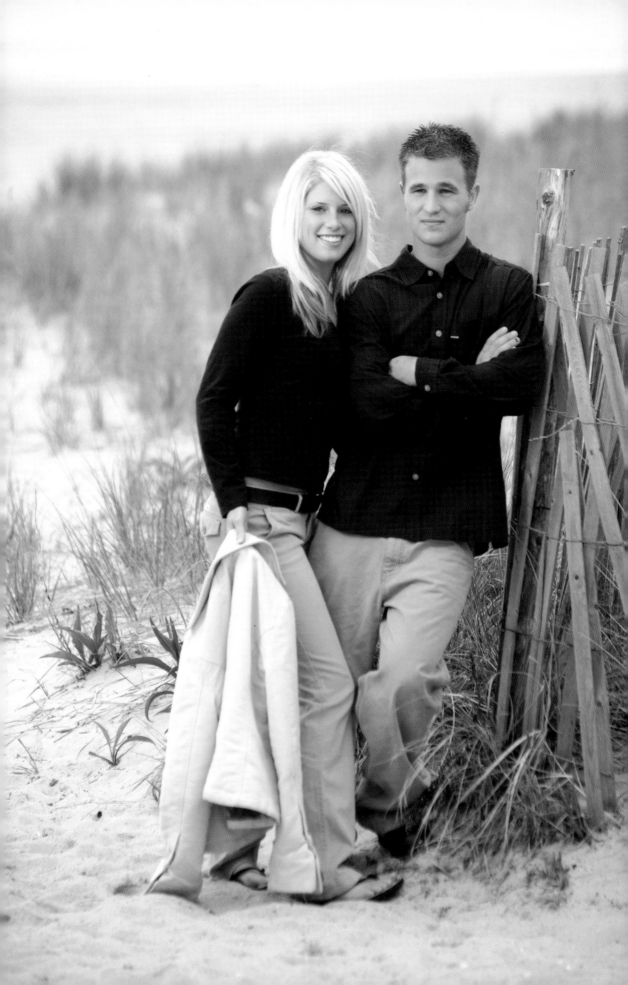

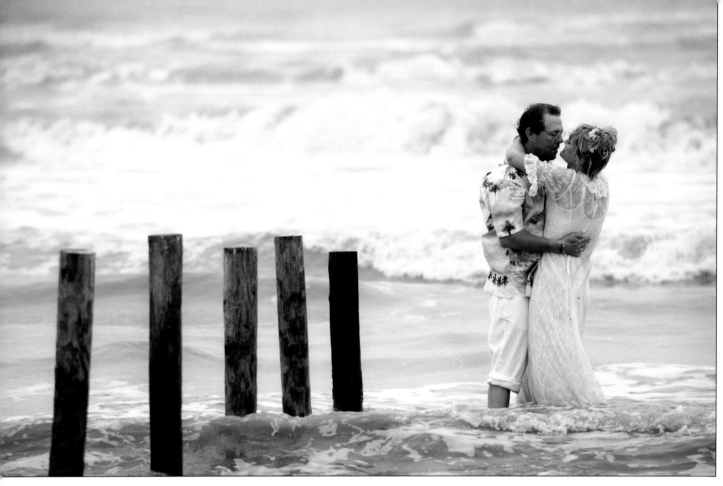

There's a lot of romance in the images on this page. Though the surroundings are beautiful, the water does not detract from the couple's magnetism. In each image, the couple's arms encircle one another. In the above image, the differing head heights add a dynamic feel that is reinforced by their position in the right-hand third of the portrait. The images lack a horizon, which could draw the eye away from the couple; also note that the waves appear to be rolling toward the couple, sweeping the viewer's eye toward the subjects. The image on the left was a natural progression from the first. The curves through the arms and the woman's arched back add interest in the image and create a sense of movement that engages the viewer.

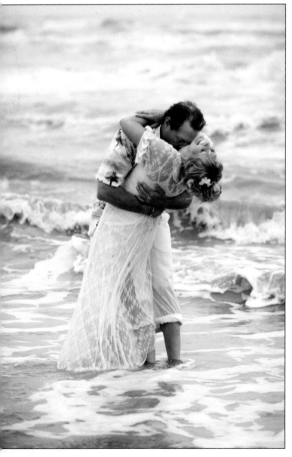

There's so much passion in these images that the beautiful backdrop almost disappears. The posing is simple—one that a couple might fall into naturally. There are times when you can watch the couple's interactions and take a great shot—but you can usually suggest a couple of small changes that will go far to create a more polished, artistic portrait.

Posing the Bride and Groom

I love to photograph brides. Though many of the basic posing guidelines for posing women and men are also used to photograph brides and grooms, there are some unique considerations when it comes to photographing the wedding couple. There are unique props, important details, and a requirement for producing portraits with a romantic feel.

A Growing Trend

Though it has traditionally been considered bad luck for the groom-to-be to see his beloved before the wedding, many smart brides are opting to participate in a pre-wedding photo session—whether on the day of the wedding or at an earlier date. The reason? Wedding images are important, and wedding days are typically quite hectic. Scheduling a special session is a great way to ensure that you get some great posed images without worrying about meeting all of the harried timelines or taking the bride and groom away from their festivities, family, and friends any longer than is necessary during the event.

In this portrait, the lines of the architecture help to draw the viewer's gaze to the couple's expressions. The pose is romantic, dramatic, and dynamic. The gown, as the brightest element in the image, is pleasingly prominent and holds detail. The pose is relatively simple and direct. The difference in head heights, the linked hands, and the positioning and pose of the bride's right hand keep the eye "trapped" between the couple.

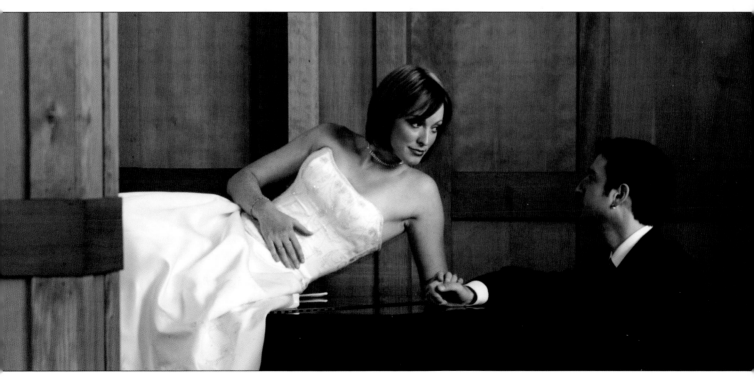

Simple Rules, Great Results

When posing the bride, we typically have at least three important image elements to consider: the woman, the gown, and the bouquet.

To help ensure the subject's comfort, I like to discuss my objectives in posing her. Some of the things I recommend follow:

- Make sure your gown is not wrinkled when you arrive for your session. (I've tried to hide a wrinkled gown; it doesn't work!)
- Relax, think about the wedding, and why you're getting married. I want to capture that glow that all brides have.
- Put your weight on your back foot. (There are times when this is not the case in the final pose, but this is typically the starting point.)
- If a body part can be bent, it should be bent. We want to have a slight bend in at least one knee, the elbows, waist, etc.
- Center your eyes in the eye socket. When people look away from the camera, they often show too much of the eye. Centering the eye will prevent this problem.

Below and facing page—Help the bride to understand your posing objectives before beginning the session. This will help her calm her nerves and allow her to relax in front of the camera.

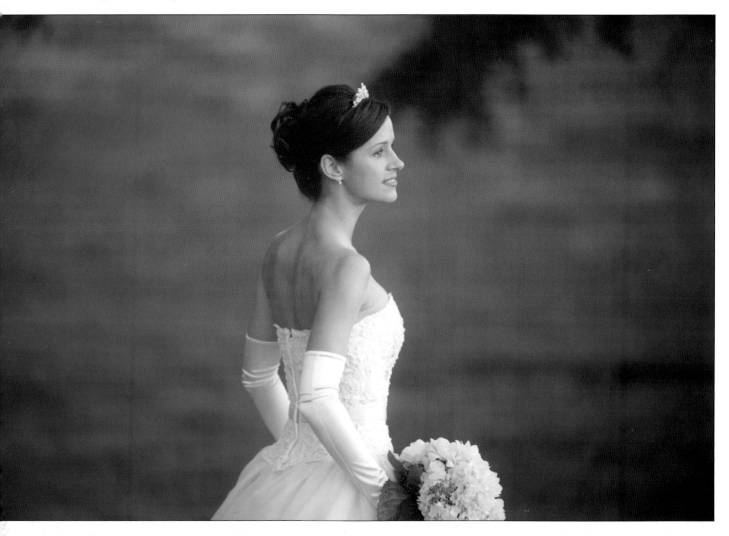

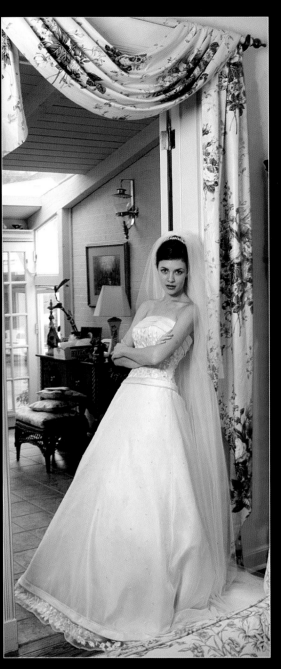

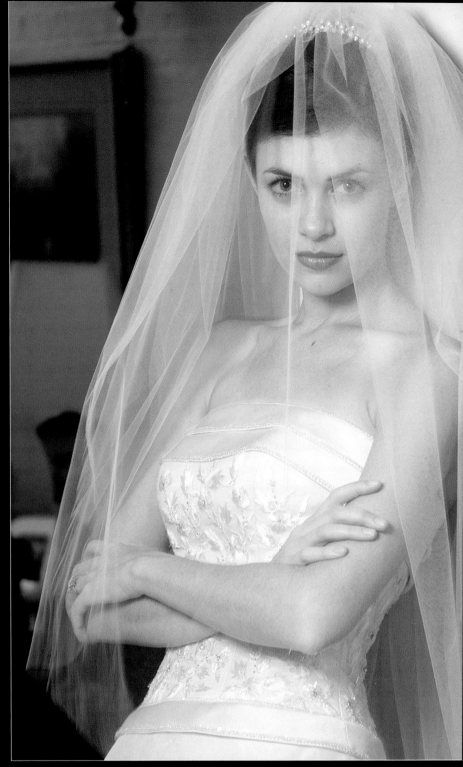

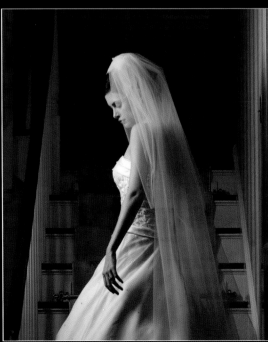

- Hold the flowers in such a way that the entire "head" of the bouquet shows. Hold them low so they don't cover the bodice of the gown.
- Don't change your position by yourself. Let me help you move; I do not want you to get your gown dirty.

If the pose looks good, capture the image. If the pose isn't attractive, don't take the picture. If you don't like something, try to hide it, crop it out, or put it in shadow. In other words, do whatever it takes to make a decent portrait great.

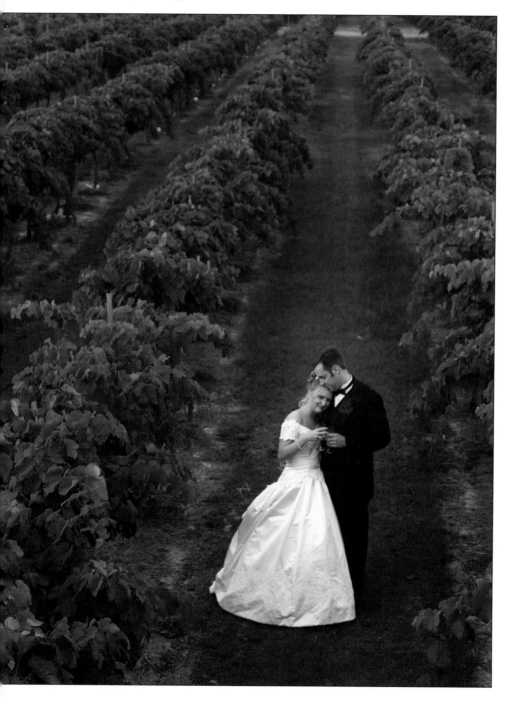

This pose is simple, but the outcome is stunning. The couple cuddles up in a celebratory toast in the vineyard. The pair has their bodies angled inward toward one another to produce a slimming view. There is a lovely S curve in the bride's body, and the couple's angled arms draw the viewer's gaze toward their contented expressions.

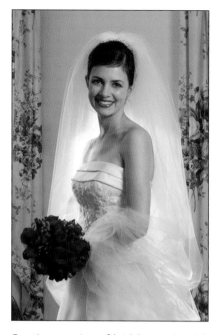

Creating a variety of bridal portraits with different poses and expressions or moods will help you increase your sales.

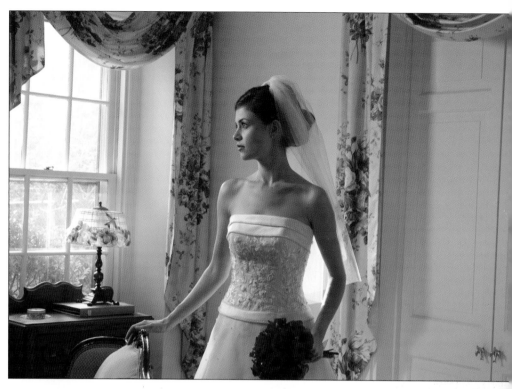

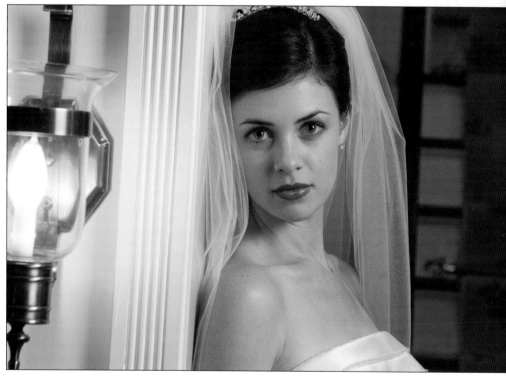

To help my engagement and bridal session clients unwind and get into a relaxed, comfortable, confident mood, I sometimes bring a CD player and allow them to play their favorite music. When your client is comfortable, it's easier to get a wide variety of poses and expressions. The above images are a good example of the variety of looks you can achieve.

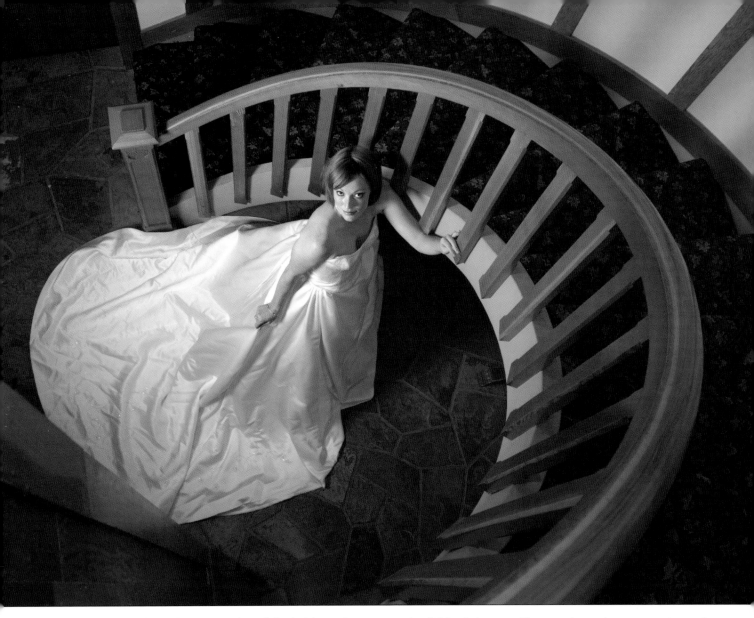

Consider taking portraits of the bride against a meaningful backdrop. This beautiful staircase was a feature of the reception venue. Compositionally, it was a gem; by photographing the bride from the top of the staircase, I was able to use the C-shaped staircase to frame the bride, securing the view's gaze on the subject. Note that her pose is dramatic, dynamic, and graceful. I had her turn her body at an angle to the camera, then look back toward me. I asked her to tip her head upward in order to capture her expression.

The sweeping staircase seems to envelop the bride, drawing the eye to the focal point of the image.

Posing Groups

When posing families or other large groups, there are many factors to co-ordinate. The challenges of posing one subject are multiplied by the number of subjects. Every individual must look good, and the group as a whole must look appealing. The image should be dynamic and engaging too. It's a tall order.

Clothing

No matter how artfully you pose your group, the image will not look well-crafted if the subjects are not wearing coordinating clothing. Prior to the session, let your subjects know that they should wear similar clothing; jeans or khakis and neutral shirts make good choices. Look at the difference in the photos on the right and below. In the image below, the group appears cohesive, and the portrait is much improved.

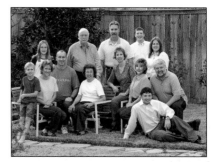

When your subjects' clothing is matched or harmonious, the group appears more cohesive. Neutral, matched clothing helps keep the focus on the faces.

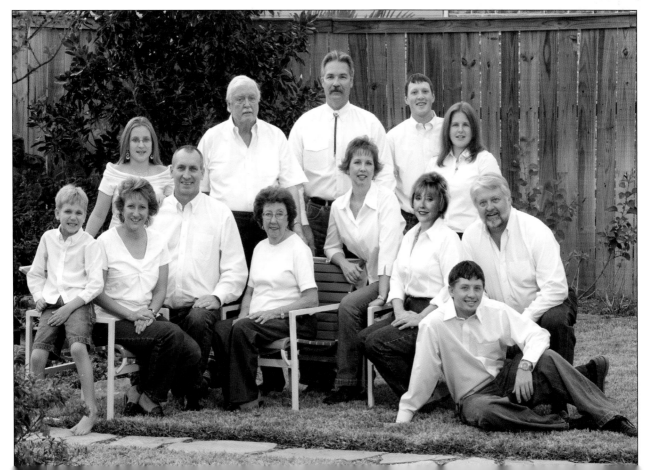

You may want to recommend that your female subjects avoid wearing short skirts, as they can limit your posing options. Also, discourage your subjects from wearing sleeveless shirts; even the thinnest, most fit subjects are sometimes unhappy with the appearance of their upper arms in their portraits.

Composition

When photographing groups, we have a couple of important compositional objectives. We want the viewer's gaze to move across the frame, taking in the face of each member of the group. We also want the members of the group to relate to one another in a way that makes sense visually. There should not be a lot of space between subjects, nor should the amount of space between any two subjects differ greatly as the eye moves across the frame.

Ideally, we want the posed group to take on an aesthetically pleasing overall shape. In the image below, the group forms a triangular shape. The little girl is posed standing and serves as the "peak" of the triangle, with mom and dad forming the "legs." The head of each subject is positioned at a unique height. This creates a dynamic feel in the portrait. Note that if the little girl were seated next to her brother, their head heights would be too similar and the "rhythm" of the pose would be disrupted.

The image below has a strong triangular composition. The little girl's head forms the "peak" of the triangle, and the mom and the dad form the "legs."

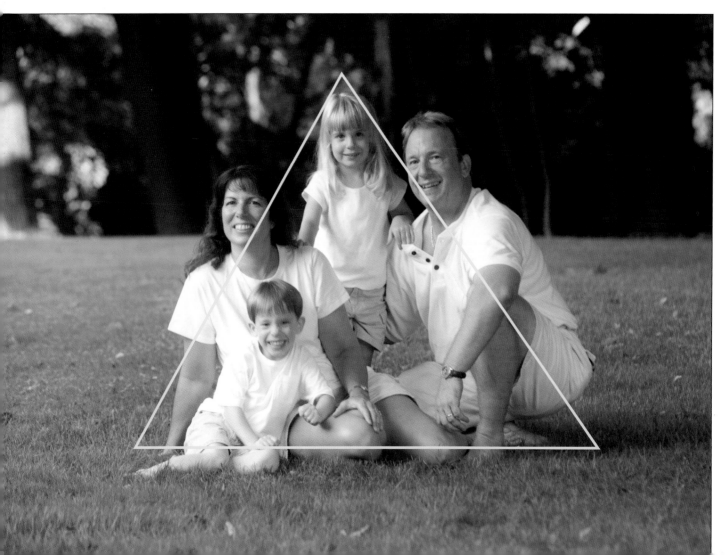

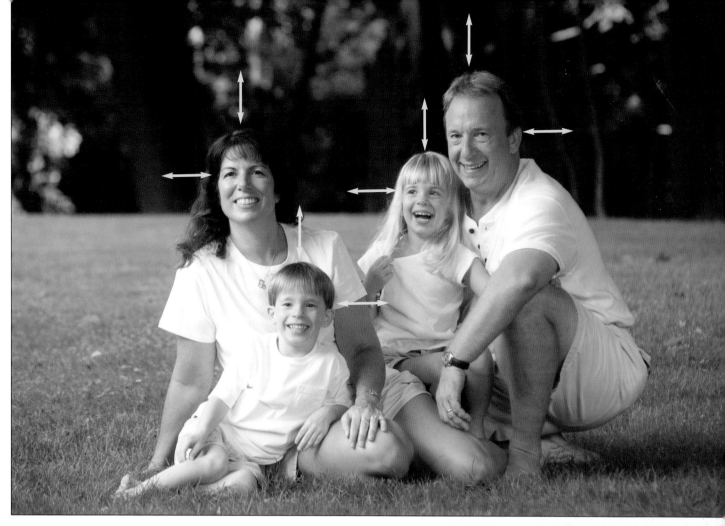

Your subject's emotional, mental, and physical comfort is key when it comes to posing. These kids were a little nervous at the start of the session, so I recommended that the family take a few moments to read a story. While they were distracted, I got the image on the right. As time went on, casual conversation and a relaxed, easy approach allowed the kids to open up, as is evidenced in the images above and on the facing page.

In the image above, the yellow arrows indicate the unique vertical and horizontal position at which each subject's face appears. When you look at the portrait, note that the eye enters the frame at the left of the image and moves from the mom's face, to the son's face, to the daughter's face, and finally moves to dad's face. There is a nice, undulating invisible line that connects all of the faces, giving the image a nice, dynamic feeling.

In the image on the right, the pose suits the purpose of the portrait. Because we wanted to show the family reading a book together, their bodies are tightly clustered, but there is still a triangular shape to the overall composition.

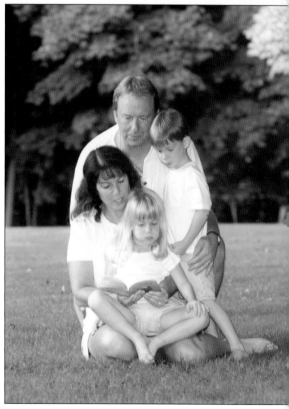

In the images below, a boulder was used as a natural posing stool. This helped to establish the height difference we desired. Note that there is a triangle shape in the grouping. With the mom's and the son's legs posed similarly and pointed toward opposite edges of the frame, we have established nice leading lines in the composition. Note, too, that no subject is square to the camera.

As you can see in the upper-left image, I like to demonstrate poses for my portrait subjects. There are two benefits to this "show, don't tell" method—first, it is efficient; second, because I've tried the pose myself, I know whether it is something that will be comfortable for the subject.

Subject comfort is extremely important to the overall success of the image. When photographing group portraits, you'll sometimes find that

Top—(left) I like to show my clients how to assume the pose I am looking for. When I model the pose for a portrait subject, I'm also able to make sure that the pose is comfortable. (right) I asked the little girl to move toward her brother to close up some of the space between the siblings, but she refused to budge. She wanted to be near her dad. **Bottom**—The empty space between the two children in the top-right image draws too much attention to the little boy and breaks up the flow of the image. The problem was alleviated by having the brother move closer to the family group and having the girl extend her arm toward her brother. The end result is a more polished, professional portrait.

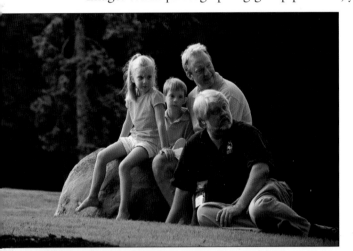

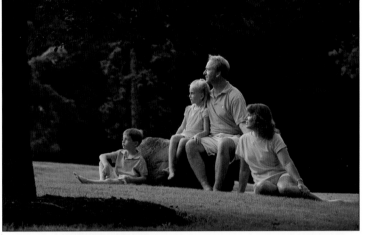

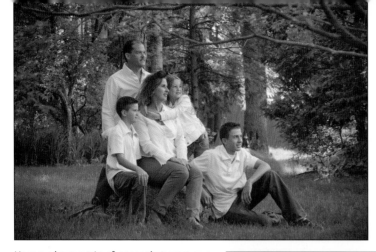

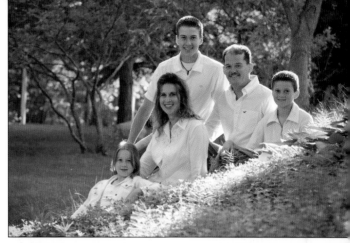

Here we have a trio of poses that meet our goals of creating dynamic arrangements in which each individual looks great.

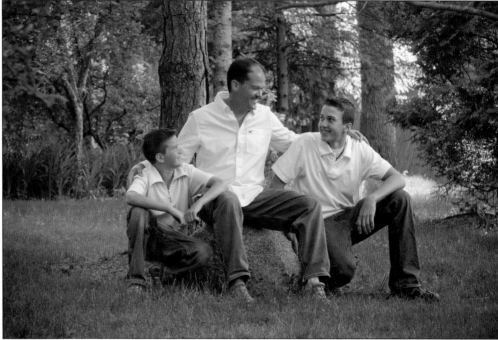

you may have to make some small concessions when it comes to composition in order to ensure your subjects' physical comfort.

Above, we have a larger family dressed in simple white shirts and denim. The casual pose is well suited to the outdoor location, and everyone looks relaxed, happy, and natural. Note that we've posed each person in a way that flatters their form, that all of the group members are positioned at varying head heights, and that the elbows and knees are bent and relaxed. In the upper-left photo, the group is posed in a two-thirds position, in the basic or "masculine" pose. In the upper right, we had the eldest son rise up slightly to form the "peak" of the triangular composition, placed the mom and dad side by side, and finished by tucking the little ones in at the corners. Note that their faces appear to be arranged in three parallel lines that match the incline of the hill on which they are seated. The third (bottom) image is a great casual pose for three. The angles in the subjects' bent knees look great, and the heads and curving line of the arms, draped across the shoulders, carry the viewer's eye across the frame.

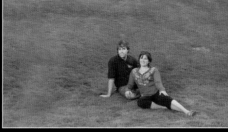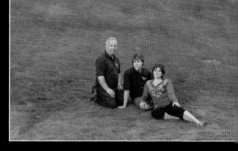
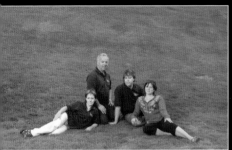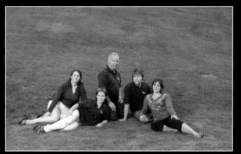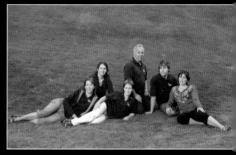
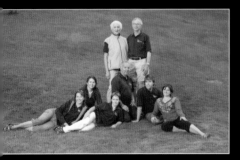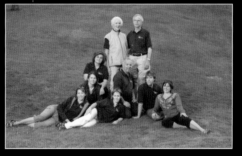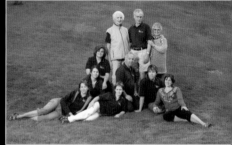
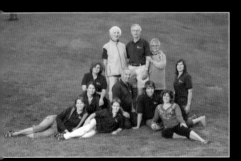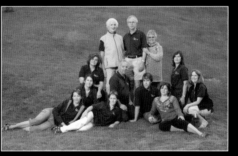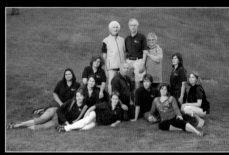
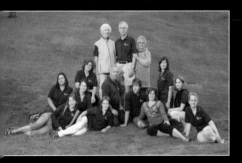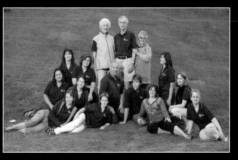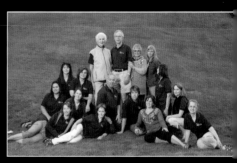
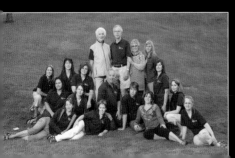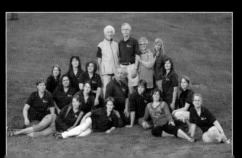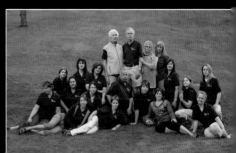

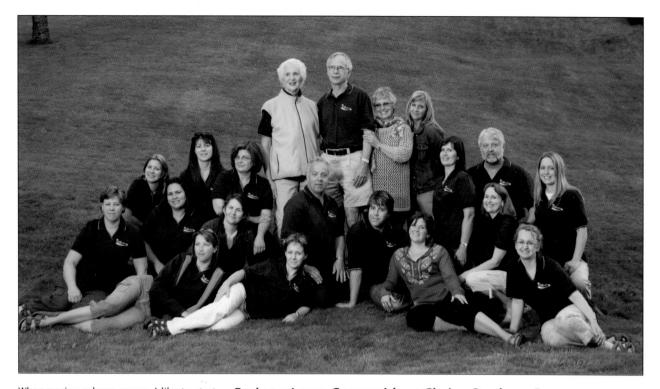

When posing a large group, I like to start by posing the youngest subjects on the ground. I gradually fill in the empty spaces in the composition with the older men and women, who may be a little uncomfortable standing for a long period of time. A note on the lighting: In all of the images except the one on the lower right of the facing page, I used an off-camera flash to illuminate the subjects. The flash also cleans up the skin tones and eliminates the dark circles under the eyes. I used the "Doug Box" location lighting system. For more information, see www.thedougbox.com.

Distortion

When photographing a large group with many rows of subjects, you might think that a wide-angle lens might be ideal. You can get closer, get everyone in the photo, and you don't have to move in too close to get the shot. Unfortunately, the head size of the subjects will appear increasingly distorted (on the small side) as the distance from the lens increases.

Posing a Large Group without Chairs, Stools, or Props

To pose the group shown above, I chose a sloped area of the lawn. This particular spot was also a good choice because it was featureless, providing a clean, plain grass backdrop.

When posing a large group, I make sure each individual's pose is flattering. I also try to put each person in their own horizontal and vertical place. Subject comfort is critical to the success of the pose. Be sure that people with bad knees are not posed squatting or kneeling.

Looking at the subjects, I try to form subgroups, based on age and height. When applicable, I also create family subgroups within the larger group. I usually pose the younger subjects on the ground, then begin to fill in the group with the older men and women.

Here's a professional secret: when I'm composing an image of a large group like this, I place each person, walk back toward the camera, then turn and look for holes in the arrangement. There is always a place to position another person—or maybe two people. Test yourself. Look at the start-to-finish posing setup illustrations on the facing page. As you review each image, look for the holes in the composition and determine where you would place the next subject. Next, look at the next image in the sequence. Did I add the next subject where you expected?

The final pose, with all twenty subjects in place, is shown above. By posing one person at a time in this way, you can pose a group of twenty—or one hundred and twenty, should the need arise. Just take it one step at a time.

Before (below) and after (right) refining the pose.

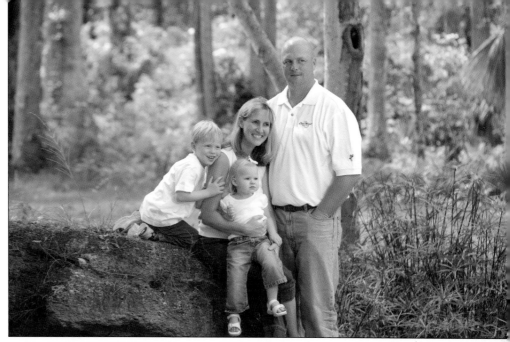

Before (below) and after (right) refining the pose.

Facing page—This portrait is a bit of a hybrid of a posed and unposed image. I placed the subjects in good light and in a basic pose, then let them be themselves.

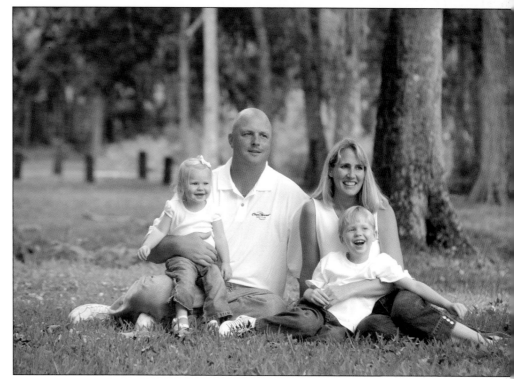

When working with young kids, you must sometimes work with what you're presented with—or some slight variation. Here, we have two before-and-after posing sequences showing a self-posed image (left) and one that I finessed to ensure a better composition. Note how getting the little boy engaged with his mom and in closer proximity to the group helped turn an image that seemed more like a snapshot into a more polished, professional portrait. Note too that by repositioning the boy, we've closed up some unnecessary space that proves distracting in the initial portraits. Sliding the dad in closer to the group also reduced his apparent size and helped create a cozier, more cohesive look.

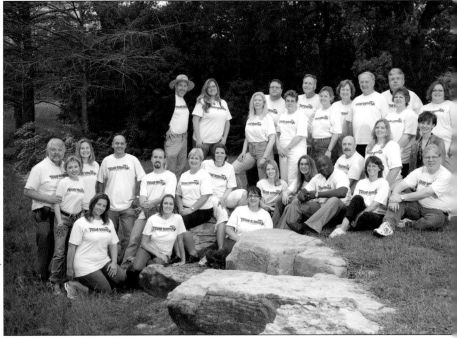

Take advantage of existing features of the landscape or architecture to create pleasing compositions when photographing your subjects outdoors.

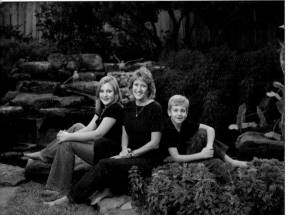

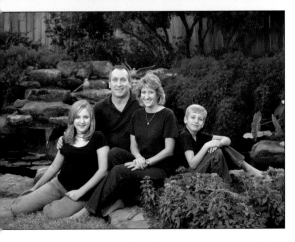

When posing groups outdoors, try to take advantage of elements in the scene to create a discrete horizontal and vertical position for each subject. In the image at the upper-left corner of the page, I posed the guys on a set of steps to create the triangular composition.

The two images on the left show a family group seated on some landscaping rock. In the first portrait, we have three subjects positioned to create a triangular shape. Each subject looks great in his or her individual pose. The body language is relaxed and comfortable, and each subject seems at ease in the environment and part of a close-knit group. In the second image, we've added the father. Note the strong implied diagonal lines that run from one face to the next, keeping the eye moving through the frame.

In the top-right portrait, we see how using sloping terrain and rocks allowed for a dynamic large-group portrait.

When posing groups, you can often use furniture to help you build a dynamic pose in which each subject is positioned in his or her own vertical and horizontal space. The series of images shown in the top row shows how we started with a four-subject pose then built up to five and then six subjects. Note that we utilized the chairs as well as one of the chair arms to build the first grouping, then also utilized the floor in order to stagger the head heights of all of the subjects.

The bottom-left image shows eleven subjects, posed with the aid of a couch and a small table. The image was created when I was teaching at the Florida School of Professional Photography, so the subjects' clothing is not coordinated. Still, the image is a good illustration of how you can pose a group of adults without a lot of props.

The portrait on the lower right shows a family of twelve posed outdoors using four lawn chairs with arms. By seating some people on the chairs, some on the chairs' arms, some kneeling, and some standing, I was able to achieve a nice composition and have everyone in a comfortable position.

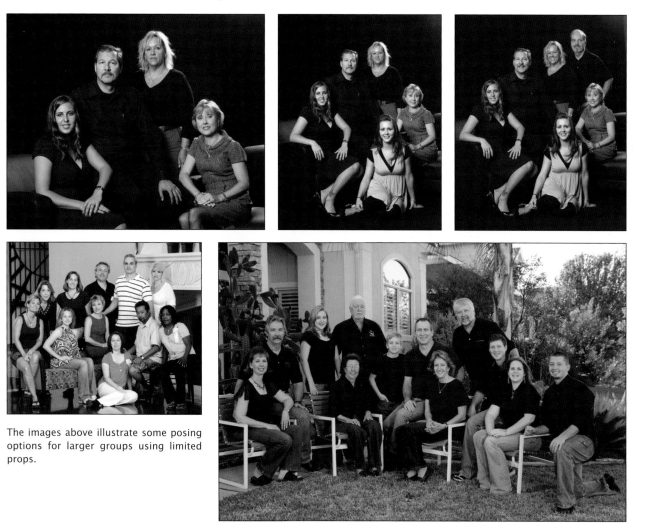

The images above illustrate some posing options for larger groups using limited props.

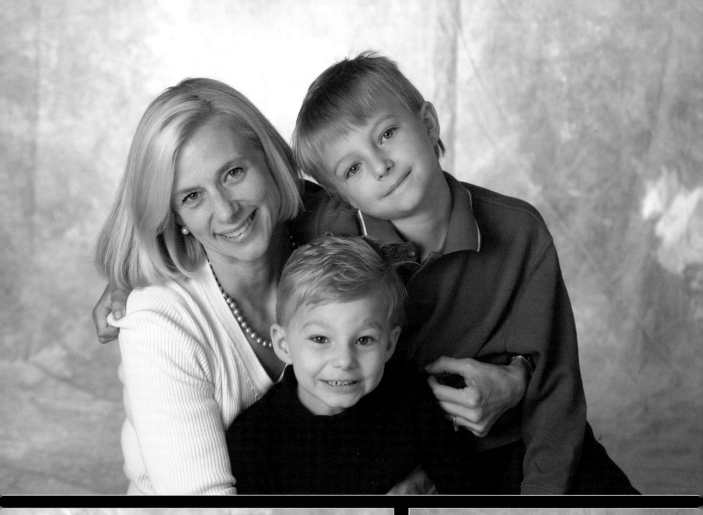

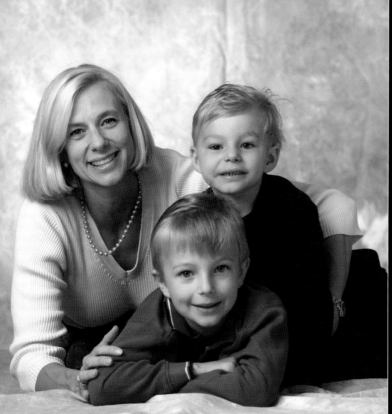

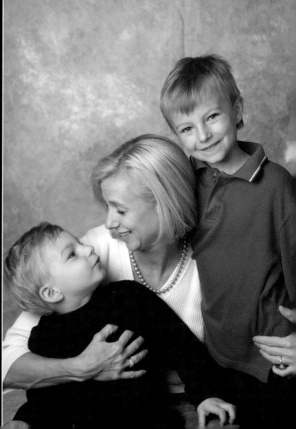

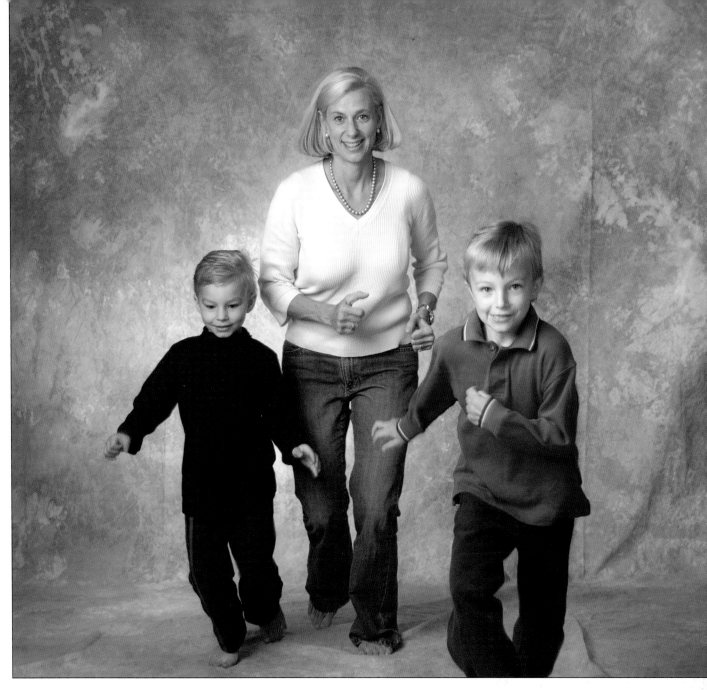

Here we have a series of images that capture the sillier, softer side of a family. As the subjects moved through a series of poses, I had to adjust the lighting and camera angle to ensure that the highlights and shadows flattered their faces and forms and showed dimensionality.

Freestyle Posing

The photo above, the trio on the facing page, and the images on the next two pages were a result of what I call "freestyle posing." The images have a photojournalistic look that is popular at weddings. Such posing works well with young clients who do not always have the patience, focus, and desire to sit and smile while their picture is taken. It's a good idea to make such sessions a little more loosely constructed and playful. You can position the subjects in an area with good light, give the mom or dad a general idea of what it is you're looking for, then watch for great expressions and tender or silly moments.

When we are more formally posing our images, it's a relatively simple task to position the subjects in relation to the lighting in a way that flat-

ters their faces and forms. With freestyle posing, great lighting and proper exposure can be more difficult to achieve. As your subjects move their positions, obviously, you must rethink your lighting strategy and even your camera angle.

Some photographers take the lazy way out and create one lighting setup that's supposed to light the subjects no matter their position and pose. To do this, they create flat lighting (i.e., both sides of the face are evenly lit). In my book, this is unprofessional. With relaxed posing and poor lighting, there's not a lot that sets your portraits apart from snapshots. We owe the clients professional images, and they're looking for not only personality but a little bit of polish when they view their proofs.

In the photos below and on the facing page, we have some wonderful examples of freestyle posing. The images show the close bond the subjects share and are proof positive that photo sessions need not be boring and stiff to be productive. In the images below, the subjects were turned slightly toward camera right. In the images on the facing page, their ori-

Left—You can sometimes get a great expression on a child snuggling up to mom or dad. This pose isn't traditional, but it makes a statement about the close emotional father–daughter bond. **Right**—(top and bottom) When creating portraits of two subjects, keep the heads at different levels and create implied diagonal lines from the eyes of one subject to the other.

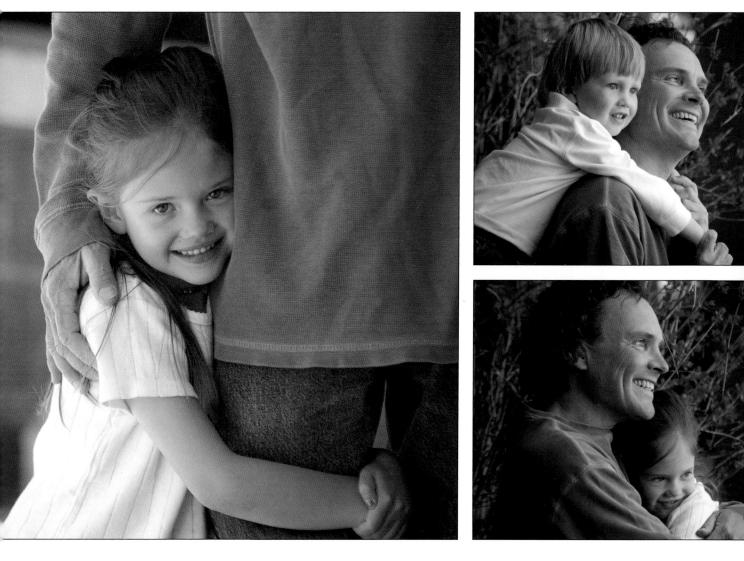

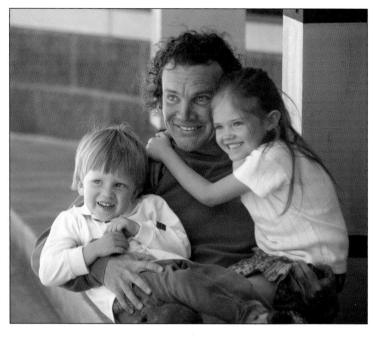

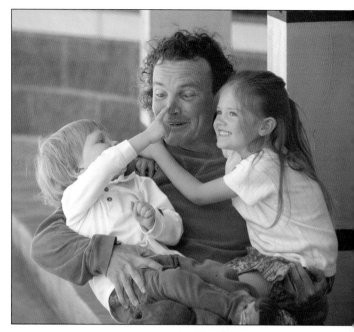

When alternating the direction in which your subject is facing, be sure the lighting is flattering in each orientation.

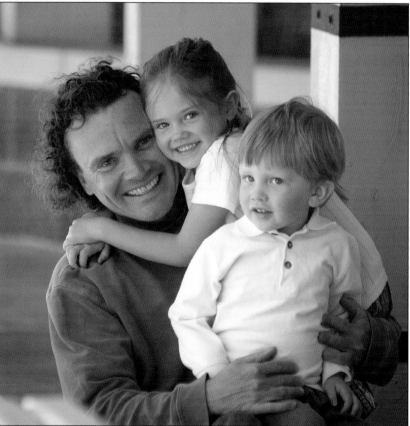

entation toward the camera has been reversed. In all of the images, however, care was taken to ensure that though the posing was a little bit relaxed, the lighting was uncompromising. When working outdoors, use reflectors as necessary to fill in any deep, unflattering shadows on the faces. Again, with casual posing, good lighting is a must.

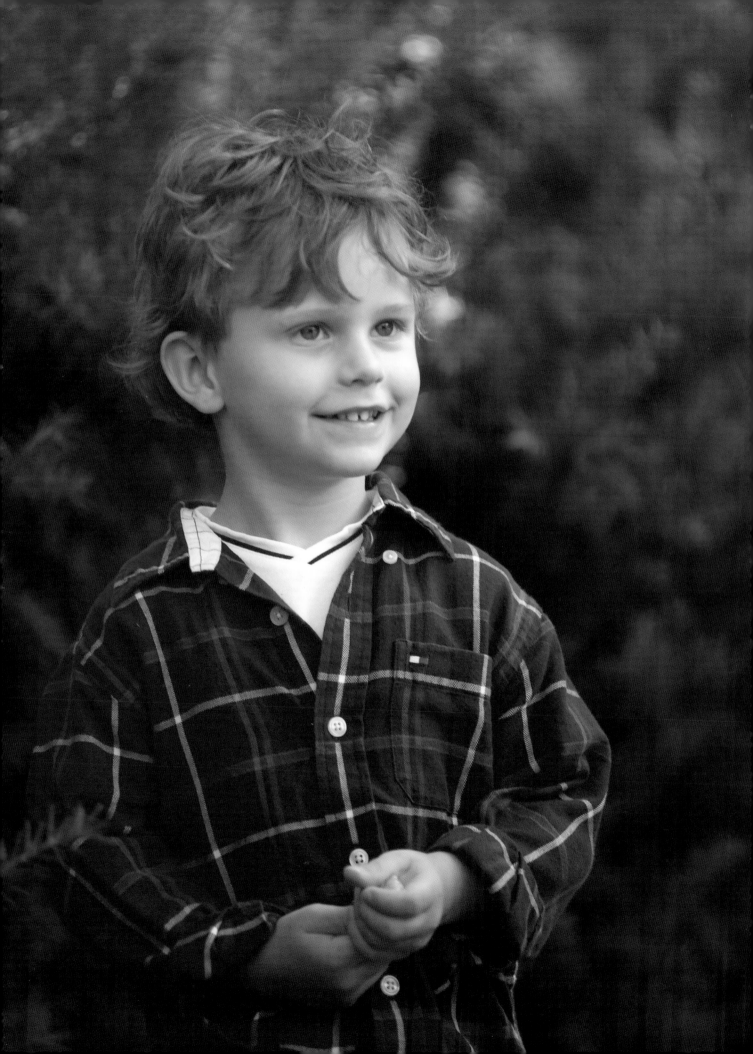

Posing Kids

Some photographers take a "spray and pray" approach to photographing their youngest subjects. They turn them loose in the studio, home, or on location, they try to engage them in something that might hold their attention while they hide behind their camera, and they repeatedly punch the shutter button, hoping they captured *something* that will make the client happy. The "pose" is natural. The lighting in these images is flat. You've seen such images time and again. They are closeups of cute expressions—happy accidents captured via flat lighting.

Getting Started

Developing rapport with young subjects will help them relax and have a good time during the session. As a result, you'll be able to capture more relaxed portraits.

You'll go farther in this business if you can develop rapport with kids. Speak to them, joke with them, engage them. Take control of the situation. Make the experience enjoyable, and set their minds at ease. A few moments of your time before you begin the session can really pay off.

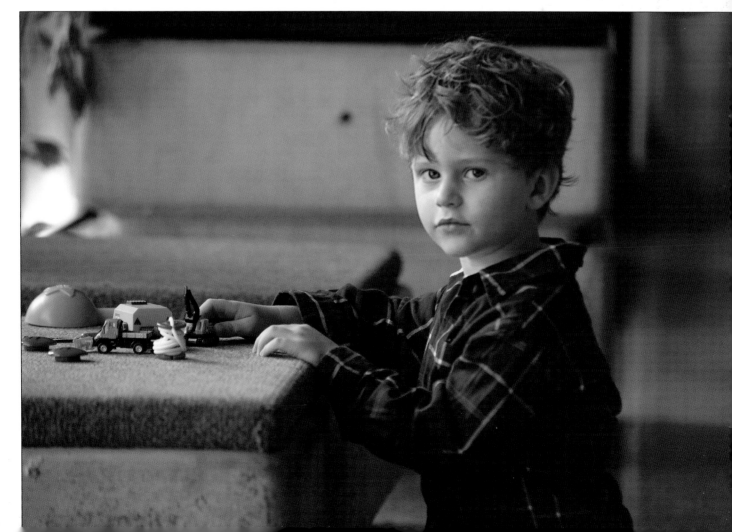

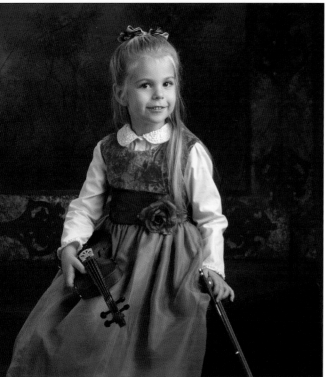

When a young client enters the studio, I personally greet them. If they are old enough to converse, I get down to their height and lower my voice, telling them what we're going to do. I sometimes whisper. I tell them I need their help.

The Tripod

If you're taking a "spray and pray" approach to photographing children, you're relying more on luck than on hard work to determine the outcome of the portrait session. I want more control over the session. I know that my clients expect—and deserve—a professional portrait of their child. This means that the pose must relate to the light and must suit the mood of the portrait, the clothing, and even the location.

My camera is *always* mounted on a tripod. This is critical. I focus with the button on the back of my camera and I *relate* to the child. When the light is right on the mask of the face and the child looks good, I trigger the shutter. You simply can't connect with your clients easily if you're hiding behind the camera.

In the images above, we have a lovely standing pose and two seated ones. Note the subtle change between the first and second seated pose. In the first seated pose, her hands are just sitting in her lap. Refining her left-hand pose resulted in the beautiful image at the lower left of the page.

The Lighting

Too many photographers fire off two hundred images with flat lighting, looking to capture closeups of the little faces animated with great expressions. To me, this is unprofessional. My portraits require good lighting on the mask of the face. I set up my lighting before the subject comes into the camera room. When the child enters the camera room, I am ready to turn my full attention to the kid, engage him or her, and capture the desired pose and expression that often arises naturally in the course of the communication.

Communication

When the child enters the camera room, I am ready. I am not hiding behind the camera. I am looking at them. I talk to them, and I explain what I am doing. The light is in place, the camera is at the ready, and when the child has his or her face in the right position relative to the light, I take the picture.

I owned a daycare for twenty years, and though communicating with kids may come more easily for me than others, you must realize that cultivating their trust will be worth your efforts. So, how do you get them to interact with you?

Showing your clients respect is a good start. Talk to them. Engage them. Ask them questions, whether they are meaningful or silly. I like to demystify the photography process for them by explaining what I'm doing. When I meter the light they are standing in, for instance, I tell them the results. Sure, the reading will likely not mean much to them, but what will have meaning for them is that you're willing to converse with them, just as you would with their mom and dad.

The images below show two different facets of the girl's personality. The light in the left-hand image isn't as nice as it is in the right-hand image, but I love the portrait—and so did her mom.

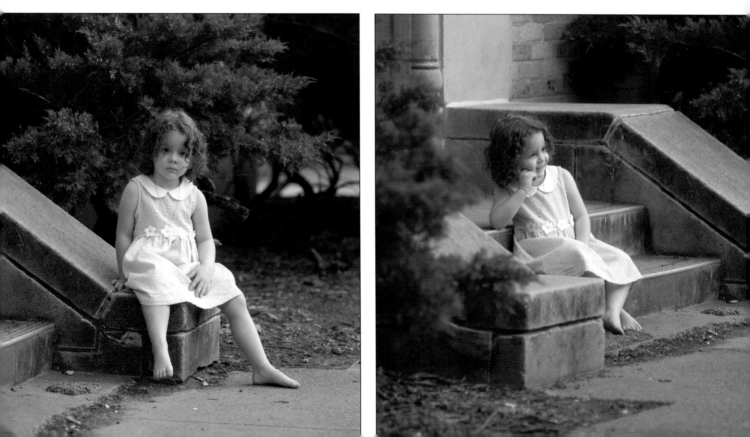

Of course, I do have some fun and games up my sleeve, too. I use dozens of voice inflections, toys, and games to engage kids. When I see a child, I'll sometimes tell them to "give me five." When they do, I loudly say "Oww!" They always look at me and laugh. There are other ways to get them to relax and enjoy themselves, too. I sometimes use the "quarter trick." I stick a quarter on my forehead and have them try to blow it off. Believe me, this little trick can make adults laugh, too. Sometimes I balance one of their toys on my head and have them try to blow it off. Sometimes tickling myself will generate some giggles.

If the child gets tired and cranky, we take a break so they can rest. I am mindful to stop photographing when I have a few great photos. In portraiture, there is a point of no return. If you wear your subject out and keep trying to capture fabulous images, you'll find that you're fighting a losing battle.

The Goal

With young children, you will often need to inspire moments that have the elements of good posing. This might involve the occasional "slight of hand." Most kids don't want to sit stock still while you fire your camera. Instead, you must incorporate play into the session and wait for the right moments. For instance, you can have them snuggle up with Mom. You might instead try to capture photos of a child playing, waiting until he or she turns their head to a flattering two-thirds position to talk to their

Here we have a fun series of images of a little girl and her parents. As I was conducting the session, I noticed the dad had big biceps and recommended the pose on the facing page. The mom said her daughter hung off of her dad's arm all of the time. Needless to say, the image was a hit.

The Quarter Trick

Take a quarter and press it firmly against your forehead. It will stay there. Have the subject blow the quarter off your forehead. As they blow, raise your eyebrows as if you are surprised. The act of raising your eyebrows wrinkles the brows, causing the quarter to become "unstuck." When it falls, catch it in your hand. You can make this trick work dozens of times.

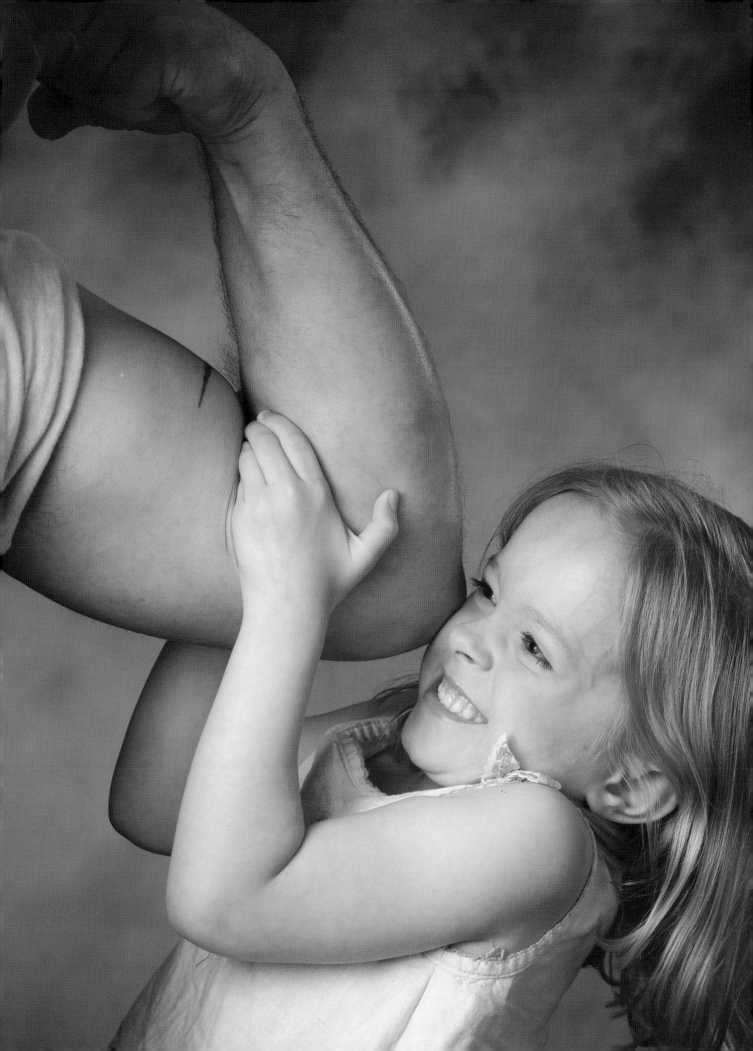

"strategically placed" mom. You can also engage the child in conversation and wait for an irresistible expression, have the child show off a special skill or talent, etc. Of course, when you're working with multiple subjects, you can photograph their interaction, as was done in the images below.

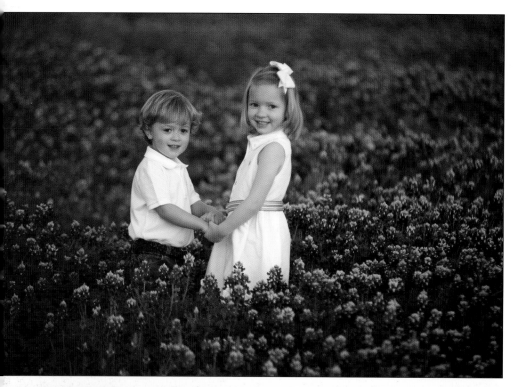

Left and below—Parents love interactive photos of their children. Here, the duo was photographed as they interacted naturally. With the children placed in a good lighting situation, against a beautiful backdrop, getting the image was a matter of inspiring an attractive presentation to the camera. **Facing page**—Older kids are better able to understand the goals of the session and will tend to work with you to create great images. After all, at this age, they want images that portray them as they see themselves. Here, the skateboard adds a storytelling quality to the portrait session, and clearly helped to put the subject at ease.

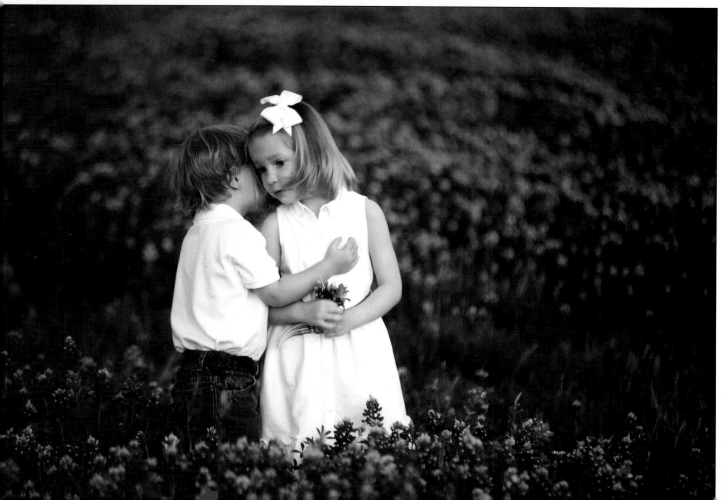

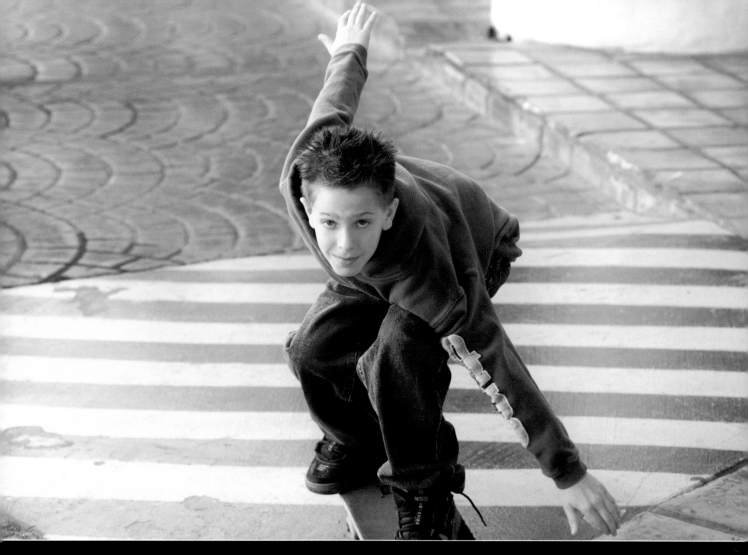

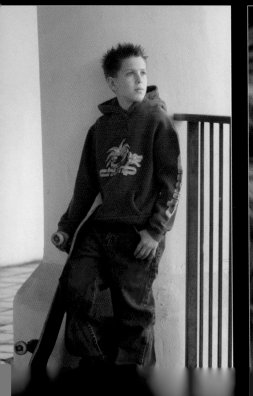

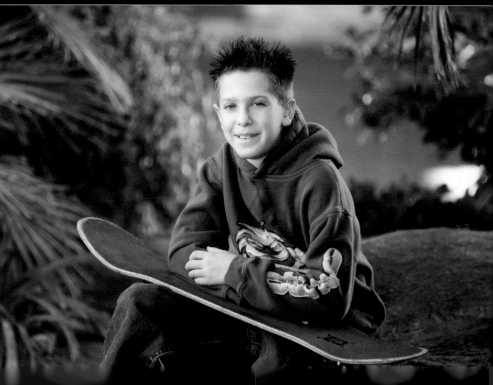

Don't overlook nonsmiling expressions when looking for great portrait opportunities. The image above and on the facing page are evidence that there are great portrait opportunities beyond the standard "say cheese" shots.

The older the child, the more fruitful your recommendations for posing will prove to be. They understand the goal of the session, have a vested interest in looking great, and are generally more cooperative than younger subjects. Earlier in this chapter, you saw a series of images of an avid skateboarder who was comfortable in engaging with his skateboard. The prop added a great storytelling aspect to the images and made a statement about who he is.

Posing and Expression

Above and on the facing page, we have examples of portraits captured while the kids simply responded to their environment. Though older kids understand that they need to "play" to the camera and cultivate a "look," your younger subjects have purer reactions to their environment and to the people around them. Kids have such a range of unscripted reactions to the world around them. Photographers should never hesitate to capture images in which the child is serious, contemplative, or even mischievous. Such images appeal to parents and will help increase your portrait sales. Many photographers hesitate to capture portraits unless the subject is wearing a toothy grin. Parents love them, of course, but they love the whole child, and they respond positively to heirloom images that capture the mood and personality of their children.

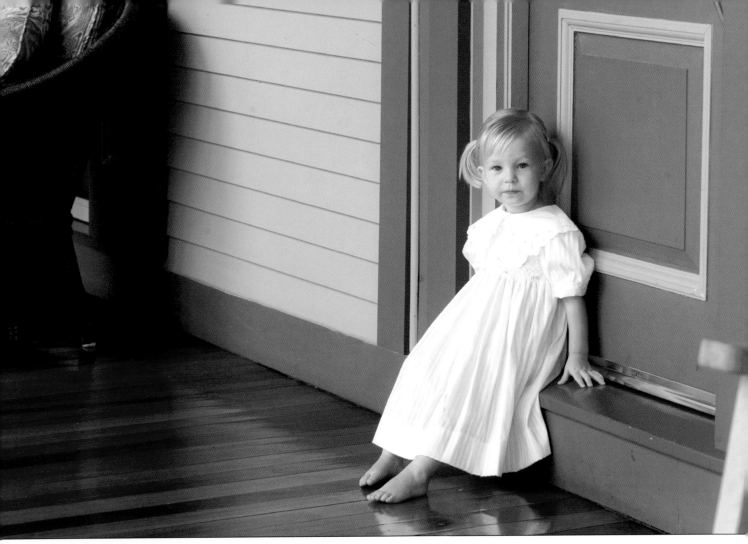

Here are a couple of portraits of kids being kids. Both poses chronicle a moment in time and show how very small and innocent the subject is.

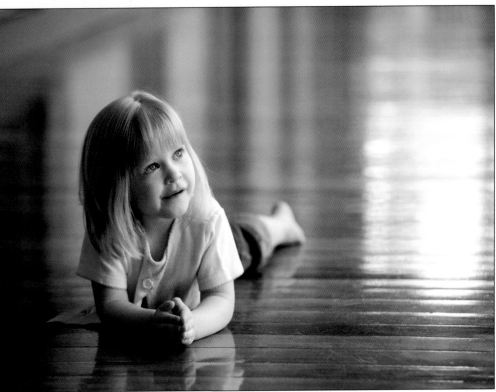

Setting Your Work Apart

Everyone and their brother seems to have a digital camera these days, and many folks can produce reasonably good portraits using their camera's automatic settings. It's our job as professionals to produce spectacular photos that stand apart; if we can't, we simply won't get our clients' business. Why should they pay for something that, in their minds, they can create themselves?

Most amateur photographers are not well versed in the finer points of posing, composition, and lighting . . . so, as professionals, producing images that pack a punch is our bread and butter. Watch for perfect lighting. Eliminate distracting elements. Make sure your composition is artful and creates a dynamic feel in the portraits. Use lenses and camera settings that your clients' point-and-shoot cameras don't offer. Make a different, stand-out portrait; nurture your client relationships; and make the session special, stress free, and memorable. As an artist, you can and should deliver something that exceeds your clients' expectations from the minute your clients enter the studio to the moment they leave with their prints. Sure, the parents of the young kids can take snapshots of their kids on the playground—but placed side by side with mine, theirs will pale in comparison.

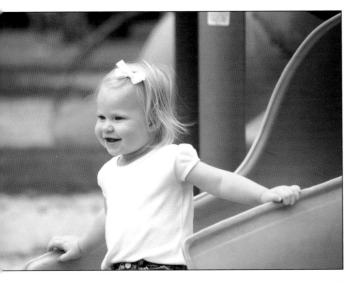

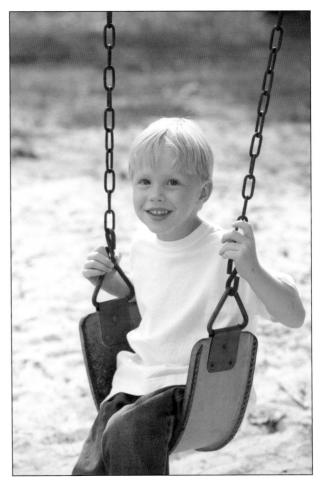

These photojournalistic photos were taken during the "reward" portion of the session. These kids posed with Mom and Dad for some more formal portraits, and the playtime was a treat for a job well done. Of course, it gave me the opportunity to take advantage of the beautiful light and happy expressions along with some "inspired" posing.

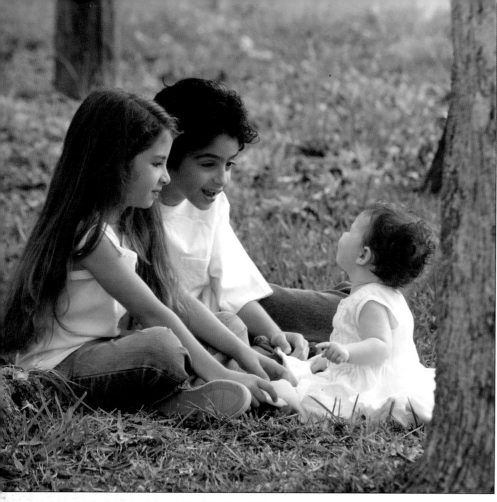

The images shown here (left and below) have a much more relaxed, casual feel than the more traditional, refined, and structured pose shown on the facing page. Both image types have a certain appeal and meet different portrait needs.

Casual vs. Traditional

The images on this page have a casual feel that's well suited to the clients, the clothing, and the locale. The subjects are comfortable, and the expressions are genuine. The moments were "inspired" by my interaction with the clients, though there was no formal posing. The portraits work; the lighting, the composition, and the expressions are polished, and the result is a professional look.

On the facing page, we have a more formal portrait that utilizes a traditional pose. The subject's body is turned away from the main light and her face is turned back toward it, beautifully rendering the mask of the face. Everything about the portrait is subdued and graceful.

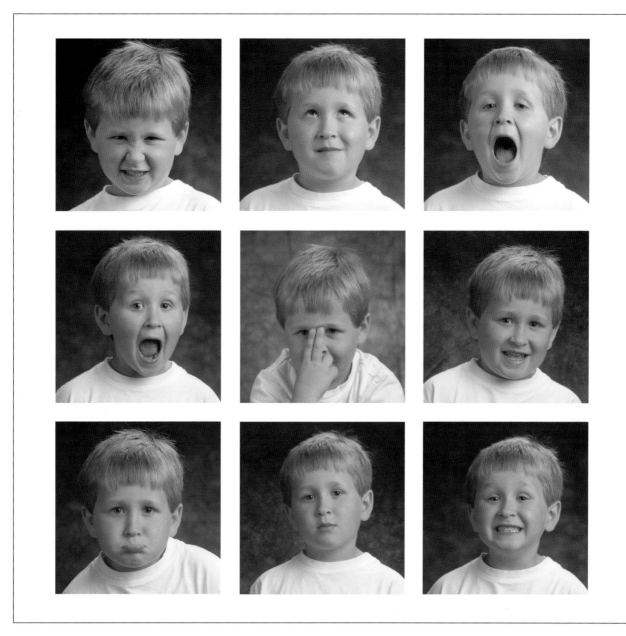

Though most outdoor portraits of children have a more casual feel, there's no rule stating that studio portraits need to be traditional or even serious. In the head and shoulders series above, we've put the focus on the many moods of the subject. Needless to say, we managed to capture a little of his personality, creating an image that will evoke memories for years to come. Though the basic pose is the same from frame to frame, we've created a great deal of variety.

A simple head-and-shoulders pose puts the spotlight on the expression. That point is made obvious in this collection, which was presented as a single, framed image.

Posing Teens

When working with teens, you'll quickly find that they have more of a vested interest in the outcome of their session than do your younger subjects. It's a no-brainer: teens want to look good. Most also want a more cutting edge look and want their portraits to reflect their unique personalities. When you look through the photos in this chapter, you'll find more inventive poses and more props than we've seen in other chapters.

In the images below, we have a teen whose interest and involvement in sports is a point of pride. Though the session was conducted in the studio, the props seem to suggest an equipment room. The pose is well suited to the concept. The body language is open, friendly, and casual. In the left-hand image, we have the front knee slightly bent, the weight on the back foot, a slant to the shoulders, and space between the torso and the arms. The golf clubs are visible but do not overwhelm and distract.

The two images below were made during a single session at a single location. The difference in the posing, lighting, and composition makes for two very different yet equally saleable portrait looks.

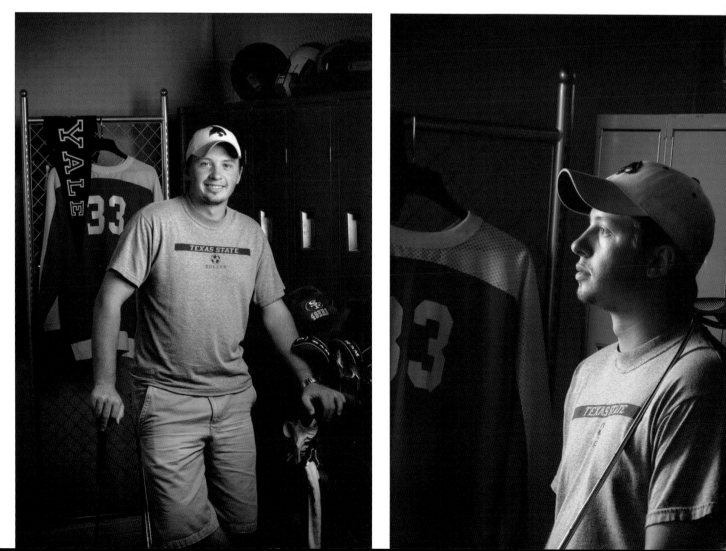

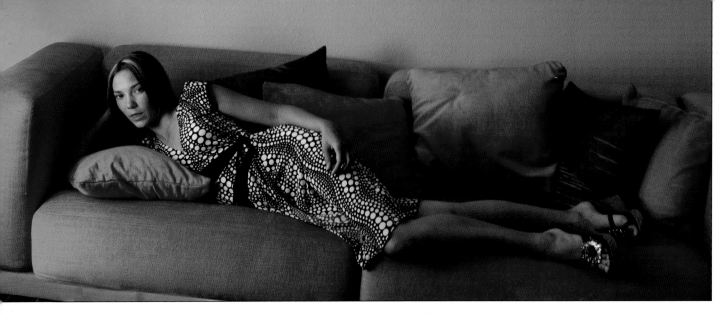

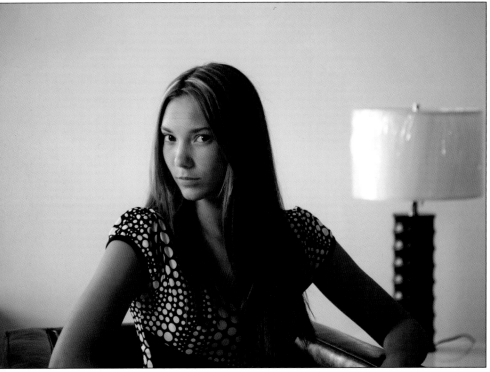

Here we have three portrait lengths—a full-length pose, a head-and-shoulders portrait, and a three-quarter-length image. Each pose flatters the teen's trim figure. The two-thirds head position was used repeatedly to show the beautiful, graceful line of the subject's face.

Posing Three Ways

These three images show a young, beautiful, and confident woman. The poses have a fashion-inspired feel that is anything but uninteresting. In the top photo, we have a beautiful reclining full-length pose. The teen's face is positioned in the upper-left third of the frame. The line of her body draws the gaze across the frame to the lower-right edge of the frame. By having her pull her left knee in front of her right knee, we emphasized the curve of her hip and accentuated her narrow waist. In the photo above, the shoulder presentation is strong, we have a nice view of her slim torso, and a very pretty two-thirds view of the face. The edgy feel in the three-quarter portrait on the facing page shows the left hand in a non-standard pose, but with the expression, the overall pose seems to work.

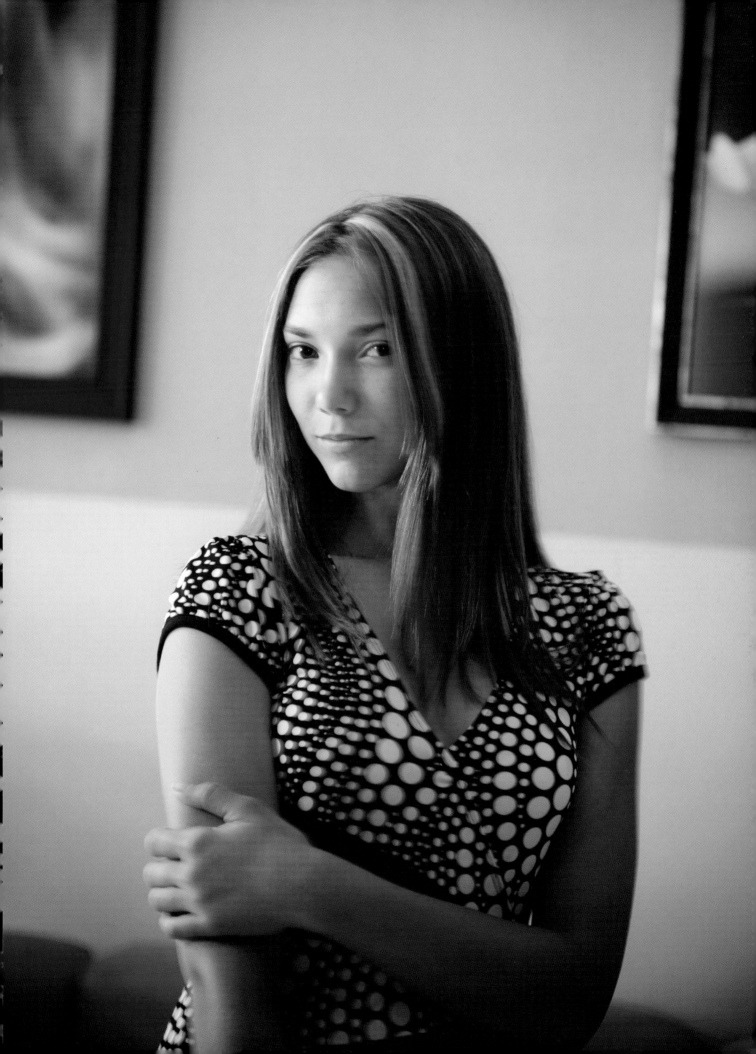

Teens like images with an edge. Consider employing interesting camera angles to introduce a unique look in the portrait.

Camera Angle

One of the easiest ways to create a tradition-defying pose is to take the portrait from an unconventional camera angle. In each of these portraits, the arm thrown over the subject's head leads the gaze to the focal point of the image—the face. In the image above, there's an implied line between the left hand and the right hand, which is delicately posed beneath the chin. Note the graceful posing of the hands. We see the edge of the hand, and the fingers are delicately bent and slightly spread. It's a traditional presentation of the hands, but even in this cutting-edge portrait context, it looks great.

Urban backdrops and casual, seemingly candid portraits are popular with teens. Note that in the images above and on the facing page, the pose is somewhat aloof and very casual. A formal pose would not suit the environment or the clothing.

Popular magazines that cater to teens—fashion, or music publications, for example—can be a great resource that can help you create poses that will appeal to teens. Consider creating a scrapbook that you or your subject (if you're a photographer who likes to give up a little creative control) can look through prior to the start of the session. By keeping on top of the current looks that are popular with teens, you can remain competitive and win referrals from satisfied clients.

Something Old, Something New

The images chosen for this chapter were selected to show the type of posing and portraiture that appeals to most teens. It's important to keep in mind, though, that the teens aren't usually the ones who will be footing the bill for your services. Create an array of poses, and make sure that you include some more traditional poses for the parents, too. Keep in mind that your "cooler" shots will be a hit with the teen, but his or her grandparents are probably looking for something a little more classic—a standard pose and a nice smile. When you create a range of looks, everyone wins.

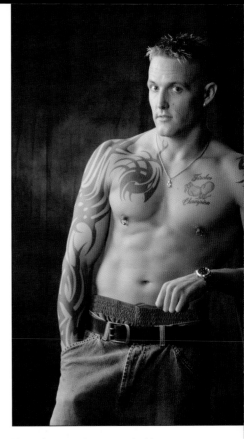

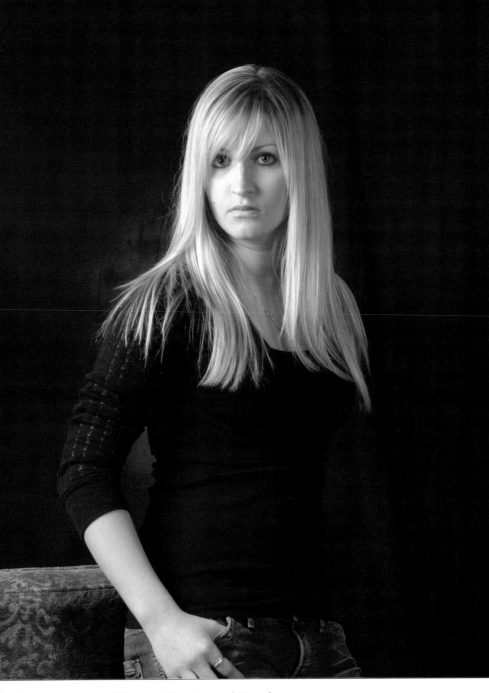

Note the way the pose, clothing, expressions, and dark tones in each of these five images work together to create a serious, edgy look.

Establishing the Desired Mood

The subject's expression is an extension of the pose. It helps to create the overall mood in the portrait and helps to give meaning to the pose. Look at the portrait of the young woman above. Her serious expression works with the casual pose and dark tones of the clothing and background to create a somber mood. Imagine the same image with a white background and the model with a wide smile. The pose would still appear casual, but the overall image would have a friendlier, warmer tone.

When photographing the male subject shown on these pages, I wanted to create some parent-pleasing shots as well as some edgier portraits that would appeal to the teen. I decided to produce some smiling portraits

while the guy was wearing a t-shirt. With his shirt removed, we have a better view of his tattoos, a great opportunity to show off his physique, and a little more attitude. Note the careful, traditional posing of the fingers in the individual portraits and the photograph of the couple. In the couple's portrait, the back of the young woman's right hand is visible. Though this is something we typically try to avoid, it works in this image, as her body language suggests loyalty and a sense of protectiveness.

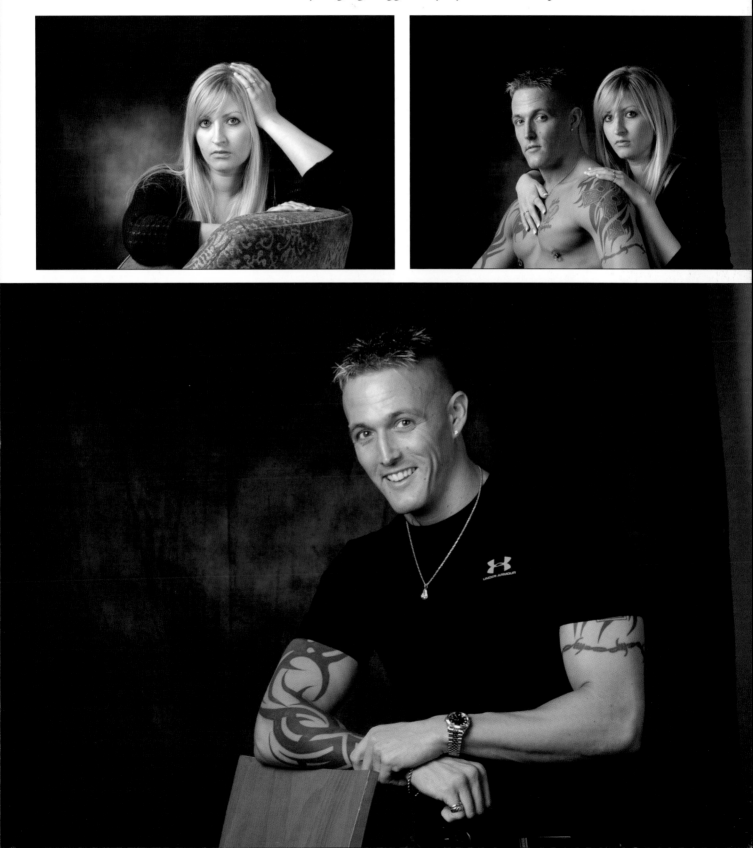

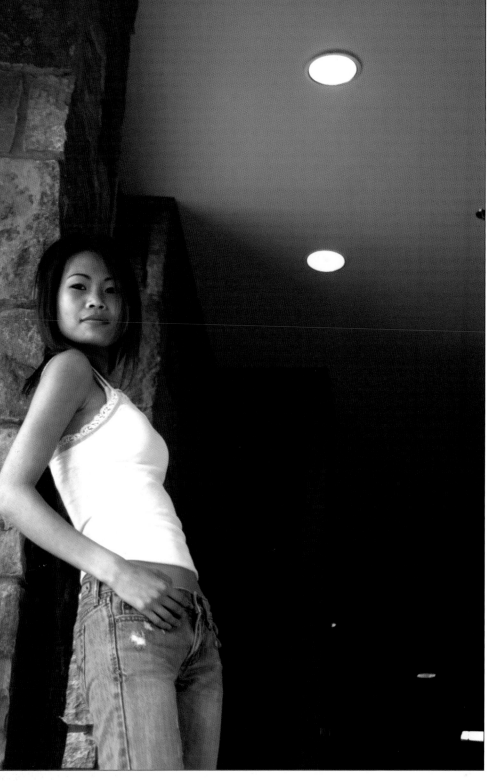

Left—The low camera angle used to capture the image on the left visually lengthens the subject's body and creates an unconventional look that's popular with teens. **Facing page**—This image has a more contemplative, softer feel. The more compact, "closed" pose creates a reserved body language that works beautifully with the expression and lighting.

A New Perspective

When posing teens, shooting from far below their head level or, conversely, from above, can help add a little bit of an edge. Note the difference the change in perspective allows in the images above and on the facing page. In the image above, the low shooting angle visually lengthens the body, making the subject appear taller. Shooting from above head height can have the opposite effect.

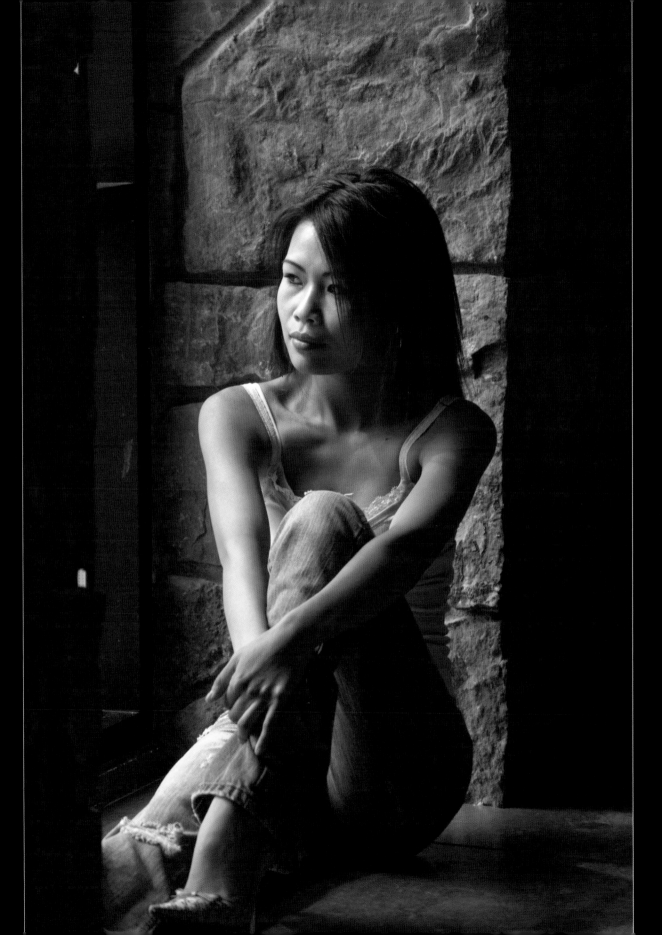

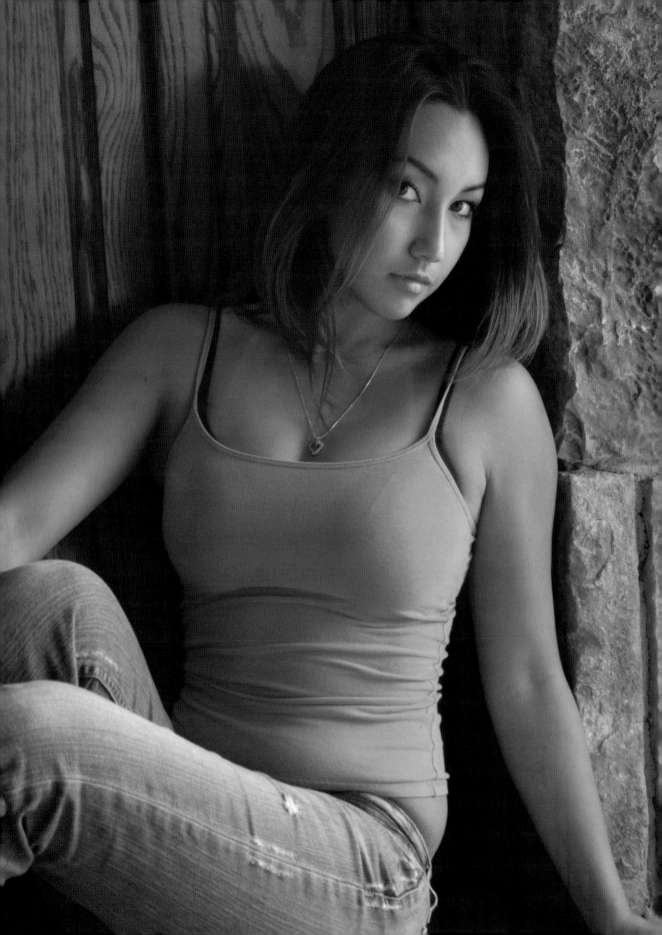

Mixing It Up

Digital photography and image editing provide us with countless opportunities to enhance our images. We can use Photoshop's Liquify tool to slightly slim the arms, for example, and can use the Healing Brush to stamp out imperfections. All will help to enhance your well-posed subject's appearance in their portraits.

Many photographers overlook another creative option that Photoshop offers: the ability to produce creative composite images. The poster below features images of my son; two of the images were captured during a game, and the others were made during practice.

Facing page—Urban backgrounds and interesting architectural elements add a little interest to teen poses. **Below**—Nik Software offers a variety of interesting plug-in filters that can help you render a single pose in a variety of ways. **Right**—An artistic composite is a great way to show off a variety of poses.

Lens Selection and Perspective

In previous chapters, we discussed the importance of flattering the body using tried-and-true posing strategies. We also discussed compositional considerations and the way that the artistic design of the image, coupled with the pose, makes a portrait appear professional. In this chapter we will look at two other factors that impact image design: lens selection and perspective.

When we are working on location—whether outdoors, at a subject's home, or in a wedding reception hall—we can't simply pull a great hand-painted backdrop or muslin into place. We must work with, or around, whatever elements the scene offers.

In this chapter, we'll take a look at how your lens selection and settings, camera-to-subject distance, and camera height can make or break the final image.

Lens Selection

Many new photographers buy very expensive, fast lenses in a quest to throw the backgrounds of their portraits out of focus. I carry two lenses with me when I am shooting on location: a Canon 24–105mm f/4 lens and a Canon 70–200mm f/4 lens. Why do I prefer an f/4 lens to the more popular f/2.8? Weight. I got tired of carrying around the extra weight, and these two lenses render the background beautifully out of focus. (Both lenses offer a handy image stabilization feature.) Remember, it is not only the physical makeup of the lens that determines focus, but also the ratio of the camera-to-subject distance and the subject-to-background distance.

Facing page—Here we have two images of a single subject. Each was taken with the subject in the same pose and in the same place. The top image was taken with a 70mm focal length setting. Note that the background in the image distracts from the subject and that her face and body appear compacted. The portrait on the bottom was taken with a 200mm focal length lens. The image is more flattering and more saleable.

Camera Height

In head-and-shoulders portraits, the camera should typically be positioned at about the tip of the subject's nose. For three-quarter or full-length portraits, your camera should be positioned about halfway between the subject's neck and waist.

Keep in mind that the closer you are to the subject, the more obvious any change in perspective will be.

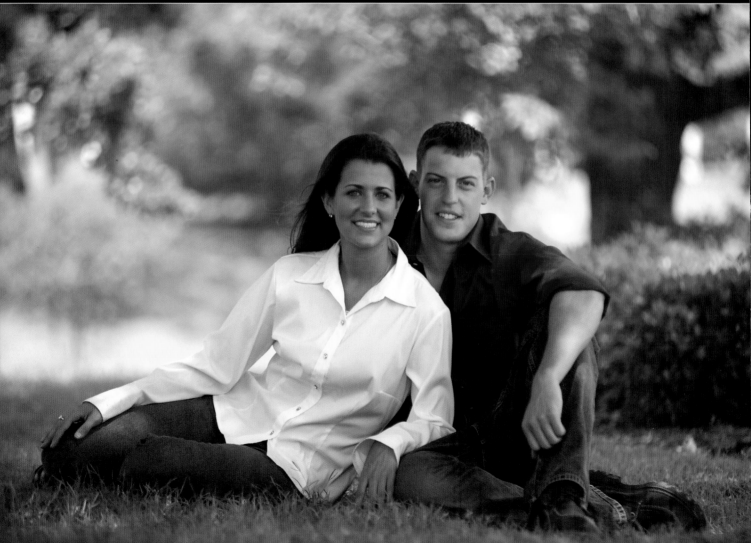

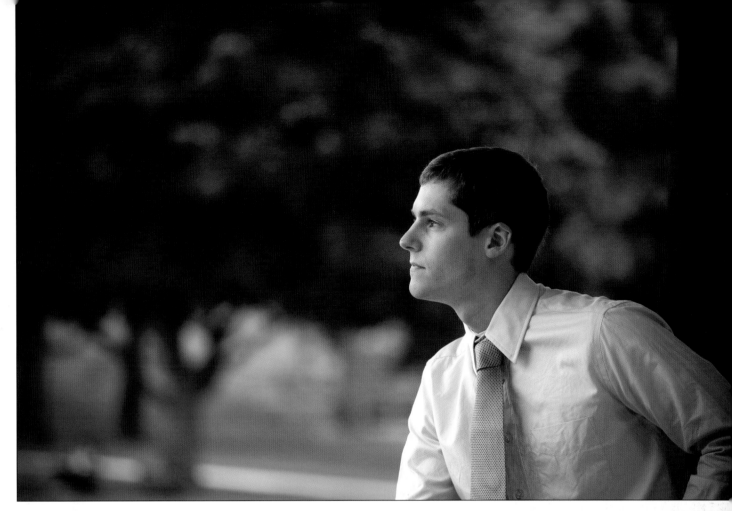

Facing page—Here are two more images that show the same view of the subject but a much different view of the background. The top image was made with a 70mm focal length setting and an aperture of f/4. The bottom image was made with a 200mm focal length at f/4. To create the bottom image, I simply backed up to include the same view of the subject. As you can see, the result is a more professional-looking, polished image. **Above and right**—I hear many newer photographers talk about "throwing the background out of focus." Many will buy very expensive, very fast (f/1.2 or f/2) lenses to make this happen. Look at the difference between the images shown here. Both images were shot at f/4. The top photo was taken using a 200mm focal length, and the bottom image was taken using a 70mm focal length. I simply backed up to include the same view of the subject. The trees, way in the background, were rendered as a beautiful, mottled, out-of-focus background.

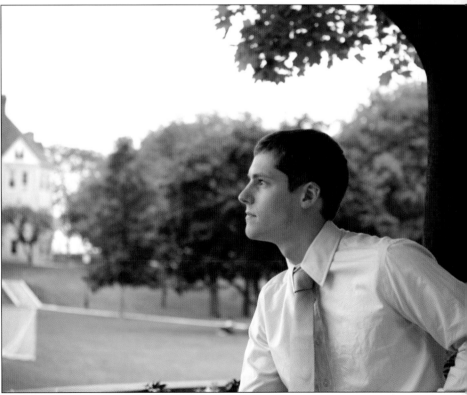

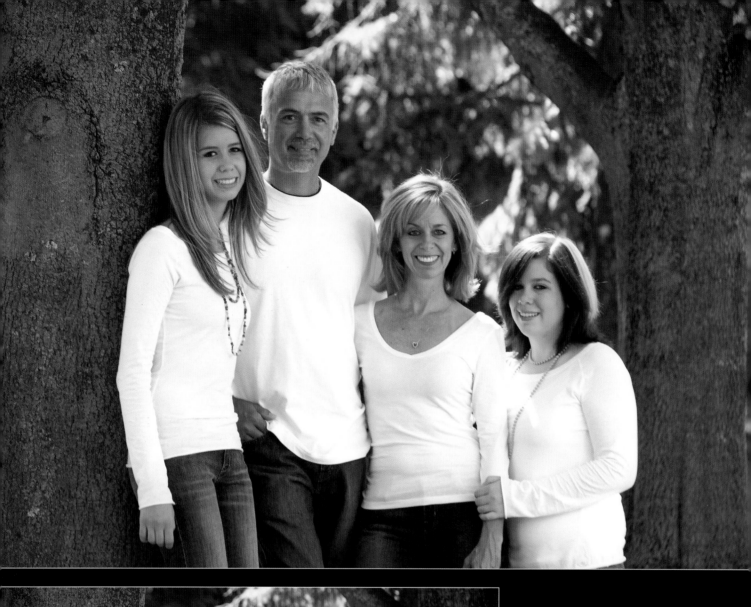
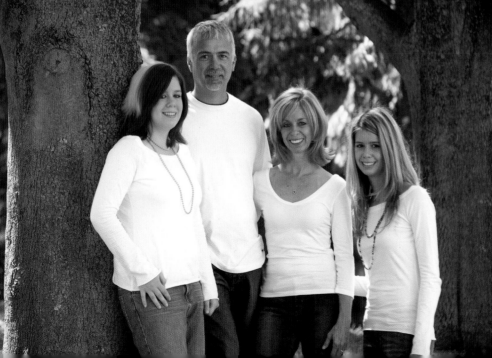

Corrective Posing

Some portrait photographers create portraits of their subjects "as is," and will not go the extra mile to make sure they present their subjects at their very best. We're not working with models, and most subjects have something they're self-conscious about. By taking some simple steps, we can enhance the subject's appearance so that when they see their proofs, they're pleased and feel good about themselves.

In this chapter, I've provided some simple tips and tricks for finessing the pose (and lighting, on occasion) to downplay your subjects' perceived flaws.

Body Size

In previous chapters, we discussed ways to pose the body to present the subject at his or her best. When you have two or more subjects, however,

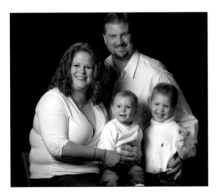

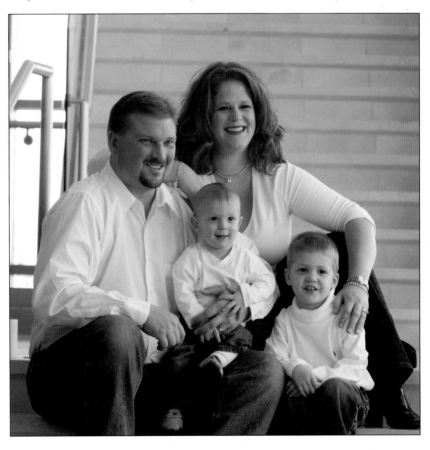

Facing page—A simple change in the posing arrangement of the group resulted in a more polished image with a more cohesive feel. Photographers often position subjects who may be insecure about their size behind a prop or another subject to visually reduce their apparent size in the frame. **Above and right**—What a difference a change in position can make! The image on the right is much more flattering to the mom than is the portrait above. Remember, posing group portraits is something of a juggling act. You must make sure the group looks great overall and that each subject seems to relate to the others in the frame. However, we must remember also that every subject in the frame must look his or her best.

Here we have a before-and-after example of the difference that a little corrective posing can make. The subject's appearance in the original image (above) was improved upon by having him lean forward, so that his midsection would not be closer to the camera than his face. I had him bring his arms across his body and rested them on the back of a chair. This change helped to obscure part of his midsection. I used a higher lighting ratio to darken the side of the face that is turned toward the camera.

and one who is perhaps a little bit larger than the others and might be self-conscious, it is a good idea to have him or her positioned slightly behind another subject. The longer camera-to-subject distance and slightly obscured view will help the group appear more uniform in size.

When working with an individual subject, you may be able to achieve the same effect using an image element like a tree trunk or a pillar. You can also recommend that your subject wear dark clothing and use a dark background. Have the subject push their chin slightly forward and raise their chin a bit. Avoid rim lighting the subject, as this will draw unnecessary attention to the subject's body.

On the facing page, there are three poses of the same family. In the first image (top left), notice the faces are all in a row. The overall appearence of the image would have been improved if each subject's face were in its own horizontal and vertical space. The women on the outer edges of the grouping are beautiful but can be posed more attractively to enhance their appearace. There are three steps photograpers can take to

visually slim their subject: you can tuck them slightly behind another subject or prop, have them stand, and/or turn them at a 45-degree angle to the camera. In pose two (top right), we've addressed the positions of the women, but the faces are still lined up. Pose three (bottom) is the best image. I positioned mom farther from the camera to create a more slimming presentation.

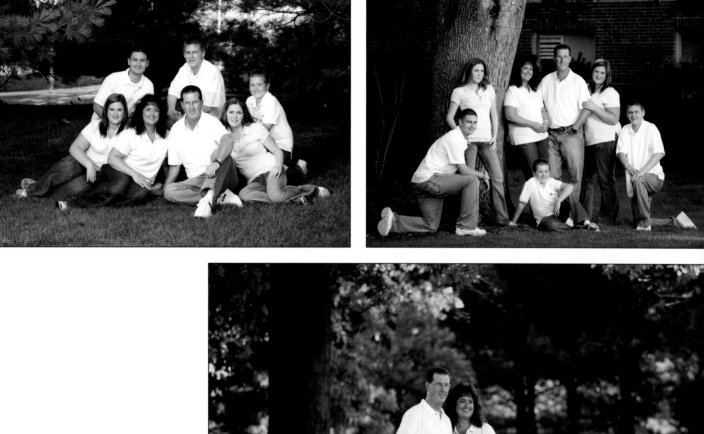

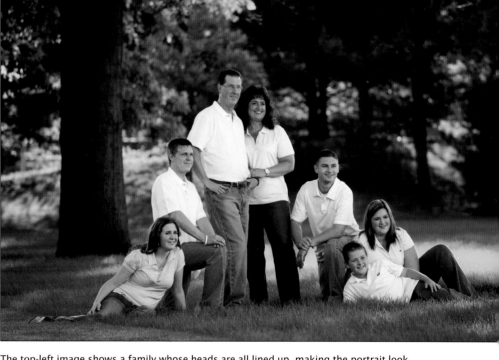

The top-left image shows a family whose heads are all lined up, making the portrait look somewhat stagnant. Also, the women are not shown in the most slimming poses. The womens' positions were addressed in the top-right photo, but the heads are still lined up. With some minor refinements, we were able to finish with a much better image (right) in which every subject looks great.

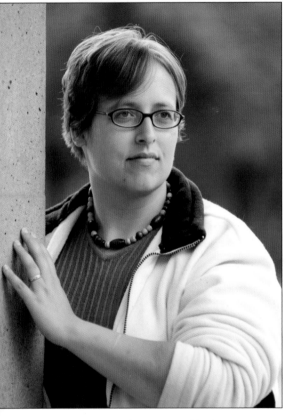

The Eyes

There are several issues involving the appearance of the eyes that photographers can improve upon by taking a few simple steps.

Eyeglass Glare. Here we have two images of a woman wearing glasses. In the top image, eyeglass glare detracts from the subject's appearance. To counter this, the subject can have an optician remove the lenses prior to the session. If the subject is wearing glasses without the lenses removed, though, there are strategies to consider. You can have the subject lower the chin, or you can raise the light (indoors), raise the camera, or raise the bows slightly to tilt the glasses downward. Outdoors, consider using a gobo in front of the face. Alternatively, you can create two images—one with glasses and one without, and composite them in Photoshop.

Deep-Set Eyes. To improve the appearance of deep-set eyes, lower the main light when working in the studio. Outdoors, you may want to decrease the light ratio by adding fill via an off-camera flash or reflector.

Droopy Eyes. To present droopy eyes at their best, have the subject look slightly upward, and make sure you get a catchlight in the eyes (you may need to lower the light slightly).

Blinks. We've all taken a portrait in which every element of the image came together—but the subject blinked as the exposure was made. To discourage your portrait subjects from blinking as the exposure is made, try counting to three, have the subjects blink on the count of two, use the mirror lock feature on your camera, and use continuous light instead of strobes.

A glare in the eyeglass lenses (top) can detract from the portrait. The are a number of posing strategies you can use to discourage the problem. The difference that taking preventative measures makes is evident in the final image (bottom).

Other Facial Areas and Concerns

Narrow and Wide Faces. For narrow faces, photograph the subject in the full-face position or use broad or butterfly lighting. Wide faces are best posed in a two-thirds head position. Consider using short lighting and a higher lighting ratio.

Square Chins, Narrow Chins, and Double Chins. Square chins look best when the subject's head is turned at an angle opposite the shoulders and the jawline is presented in shadow. Narrow chins look best when the head is presented in a two-thirds view with the chin tilted upward and a lower camera angle is used. To deemphasize a double chin, have the subject lean forward and push their chin slightly forward and upward to tighten the area and create more definition. Use a higher camera angle for the best effect.

Crooked Nose, Long Nose, or Flaring Nostrils. To improve the appearance of a crooked nose, turn the bend toward the camera and use the main light to form a straight-line highlight on the nose. A long nose can be visually shortened by tilting the chin slightly upward, lowering the camera or main light, or shooting full-face portraits. Tilting the chin downward and raising the camera height will deemphasize the nostrils.

Facial Scars or Defects. Use soft, flat lighting, hide the problem area in shadow, and try higher lighting ratios.

Wrinkles. Use soft lighting, photograph unsmiling expressions, and use digital retouching to visually *diminish*, not remove, the wrinkles.

Prominent Ears. If your subject has prominent ears, use a profile or two-thirds presentation so that only one ear shows. You can use short lighting, putting the front ear in shadow; if you are using a hair light or kicker light, just make sure the ear remains in shadow.

Flyaway Hair, Thin Hair, and Baldness. To diminish the appearance of flyaway hair, you can select a background that is similar in color to the subject's hair. You can also try to "tame" the flyaway hairs by lightly coating your hand with hairspray and wiping it over the hair. Avoid using a hair light or back light. You can also remove stray hairs in Photoshop. When photographing thin-haired or bald subjects, avoid hair lights or block light from striking the top of the head by using a gobo.

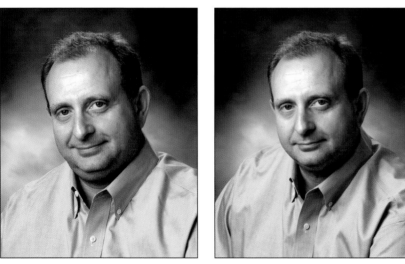

A double chin can be visually diminished by having the subject lean forward slightly, and push their chin slightly forward and upward. Shooting from a higher camera angle can further refine the pose.

Posing Variations

As previously discussed, posing kids is often a matter of positioning them in great light, interacting with them, and "inspiring" great portrait opportunities. Whether the child is old enough to follow some basic recommendations (as was the case in the images of the young man below) or just doing their own thing (as was the little girl on the facing page), we want to create great moments that show the personality, and hopefully, have the subject relating to the camera in a somewhat traditional presentation. Sometimes, our posing standards are compromised for subject comfort. In this case, great lighting, personality, composition, and a real sensitivity to seeing the unique aspects of a subject's personality can, in combination, make for a great portrait the client will cherish.

With young subjects, creating multiple portraits in quick succession is sometimes a must, as it can be difficult to ensure their participation for long periods of time. With teens and adults, capturing multiple and varied poses allow us to capture images that showcase various moods.

Below—Older children can often follow some basic posing advice, making it easier to get a variety of poses that their parents can choose from. **Facing page**—With young children, structured posing goes out the window. Your best bet may be to get storytelling images showing the subject interacting with their environment.

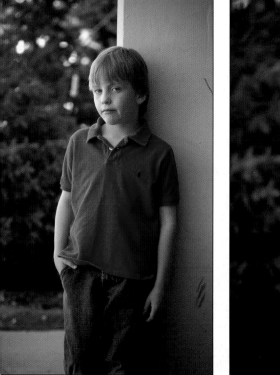 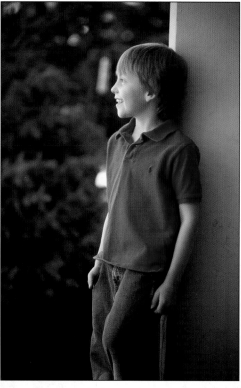 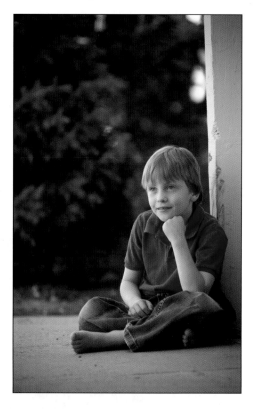

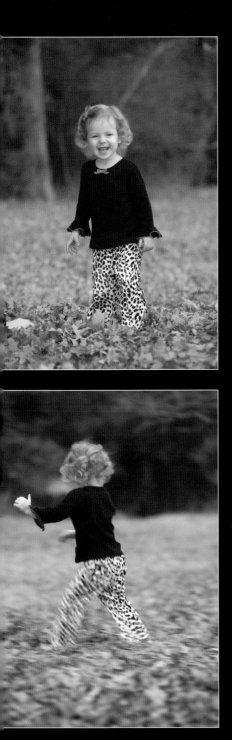
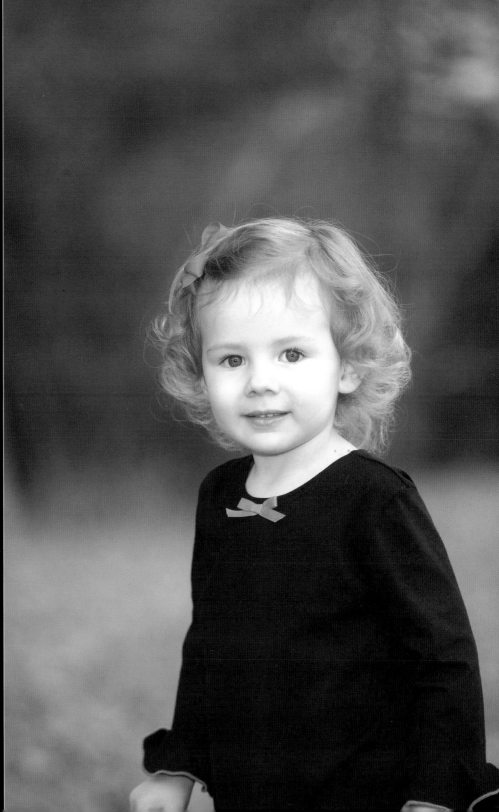

The image below is an album page created for an engaged couple. The three images shown are just a few of several portraits taken during the couple's session. We captured a variety of photographs of the couple posed together, as well as a selection of portraits of the woman alone and the man alone. Creating a variety of portraits allowed us to sell more prints. If we had just posed the couple together, we'd have likely had a good print sale; however, by photographing the man and the woman individually as well, we've effectively tripled our portrait sales options and created an album that will be an heirloom. Note the posing basics used in each of the three images. The subjects are presented at an angle to the camera, and in the two right-hand images, we have nice dynamic lines.

When posing a couple for engagement portraits, be sure to take some individual photos as well. It's the perfect opportunity to drive your portrait sales and increase profits.

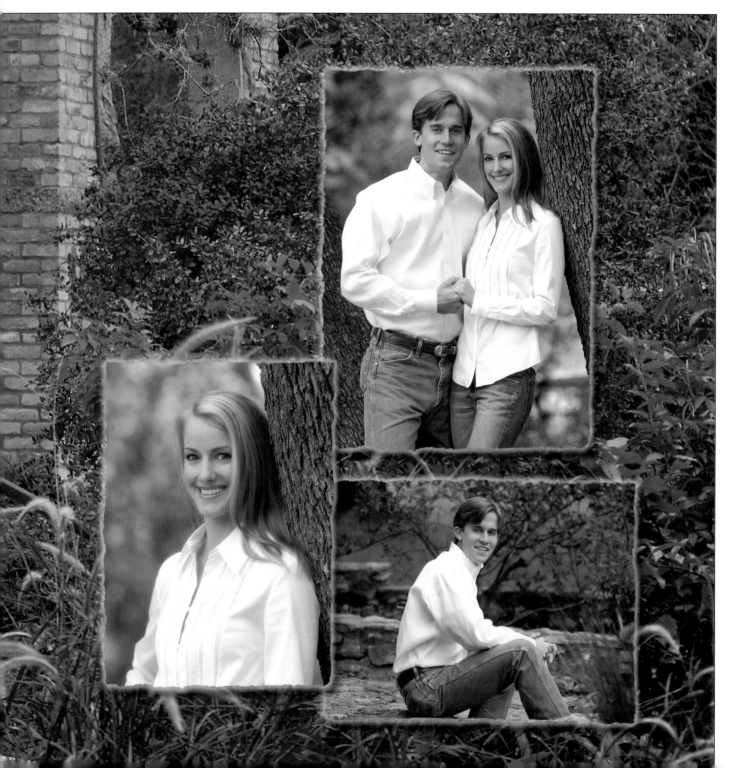

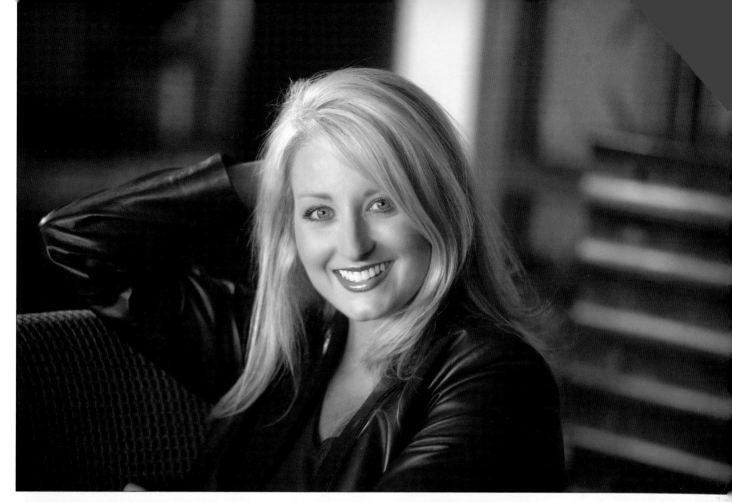

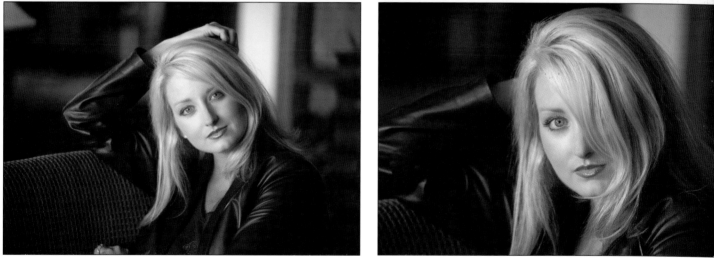

When conceptualizing poses for the session, consider the portrait recipient.

Here we have a trio of images of a beautiful woman. The subject was comfortably posed, and her relaxed demeanor shows in each portrait. There is a slight variation from one image to the next. The main difference is the expression. When creating images for your clients, ask if the subject is creating the images for a specific recipient, as this will guide you in determining an appropriate tone for the images. Though I like the image on the lower right best, if the image were intended as a gift for the woman's mother, I suspect she might prefer the smiling pose.

When "posing" our youngest subjects, safety is a primary concern. Sometimes, we must include a part of the parent's body in the frame. Even when your subject is a toddler, it's a good idea to have a parent come to the session dressed in a way that allows us to include their arm/sleeve and leg/pants in the portrait. This can provide the subject with the physical and emotional comfort and support of having their parent nearby.

Chairs and other furniture can also be helpful when photographing toddlers. You'll often see a great armchair or other padded chair or sofa included in the frame. It's typically not for decoration's sake. Rather, it provides a support for the unsteady youngster, and it also allows for a soft spot should there be an accident. Be sure to keep the area clear of sharp edges, and capture images of the child interacting with their environment.

Facing page and below—Toddlers can benefit from soft props—be it furniture or the body of a parent—to help keep them steady on their feet. Keep in mind that the portrait can often be creatively cropped to put more emphasis on the child or, in some cases, the parent's body or other supportive prop can be edited out post-capture in Photoshop.

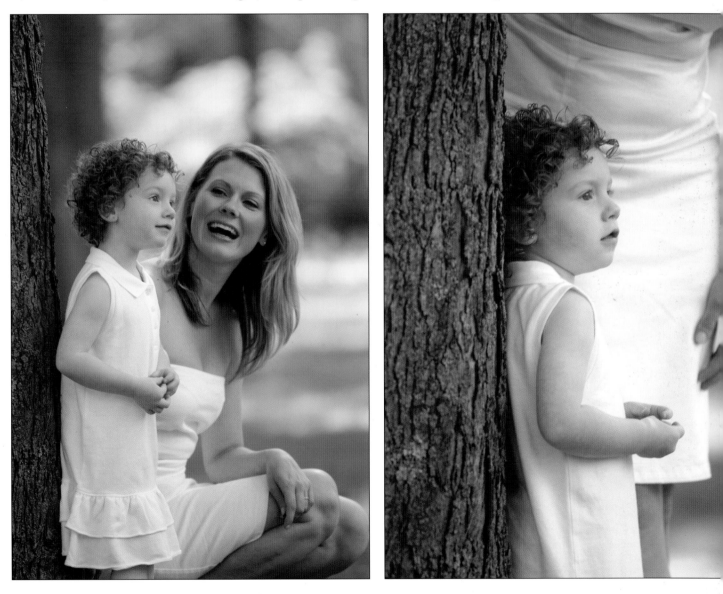

Putting It All Together

We've covered the basic principles involved in posing and composition. In this chapter, we'll look at a selection of images and talk about how the posing, image design, and lighting choices work together to make the images successful.

In the image below, the subject has a nice, dynamic pose. I probably could have moved her left hand out a little bit to give a little more flow to the pose, and could

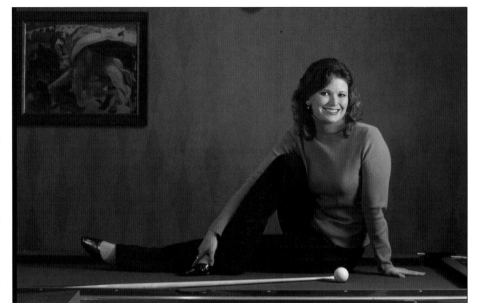

This informal, triangular pose works beautifully with the subject's casual clothing and the environment.

have bent the elbow of her left arm some. I think the woman's attire and the pose work well with the pool table.

In discussing composition earlier in the book, we talked about leading lines and the concept of tension and balance. Note that we have a triangular composition in this pose, which runs from the toes of the subject's right foot, up to her head, and down to the tips of the fingers of her left hand. The shape is repeated in the placement of her bent leg. In creating the triangular shape, we ensured that several leading lines guide the viewer's eye through the frame and to the subject's face. Additionally, the placement of the pool cue and cue ball lead the viewer's eye from the left-hand edge of the frame to the subject.

Note the way the framed artwork provides visual interest that helps to balance out the visual "weight" of the image which, due to the subject's placement in the frame, tends to be concentrated on the right side of the image.

Amidst all of the dark, more masculine tones in the image, the subject's light skin tones "pop" and quickly draw attention. Her feminine curves are a lovely juxtaposition to the straight lines in the image.

In the image below, all of the elements of the photograph come together to form a fun, dramatic portrait that is well suited to the girl's enchanting, fun personality. The dramatic, contrasty sky creates a beautiful dark backdrop that allows the subject's tanned skin tones and crisp white sundress to "pop." Note that the horizon line does not cut across a critical point of the pose and that it is positioned at roughly the lower third of the frame, making the sky more prominent than the body of water behind the subject.

The three-quarter pose has all of the elements of a feminine pose. The girl's weight is on her rear foot, her body is turned slightly away from the camera, and her face is turned back toward the camera. Her arms, held away from her torso, give us a nice view of her overall form, and the angles of the arms add interest.

At this time of day, there was little natural light to work with. I supplemented the existing light with the "Doug Box" (this is a sturdy, easy-to-use softbox I had made to my own specifications when I couldn't find anything I liked on the market) and a battery-operated flash system called the ProFoto Acute B. It's a great option if you need more power, have to use the flash repeatedly, or need a fast recycle time. See the Resources section for more information on the "Doug Box."

This spirited pose and dramatic natural backdrop helps to illustrate the subject's vibrant personality.

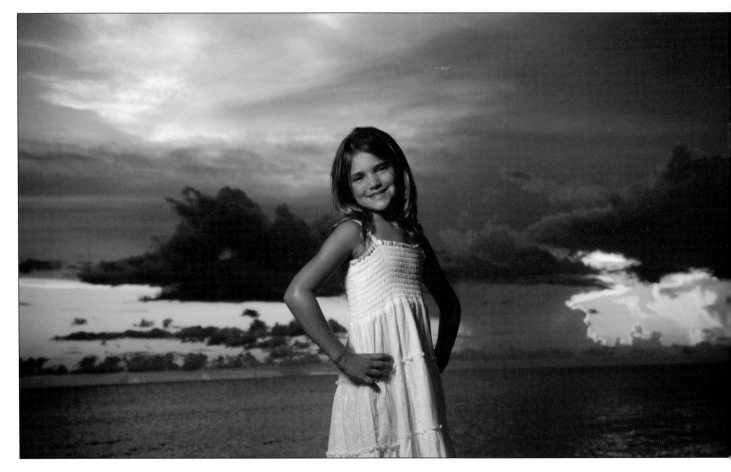

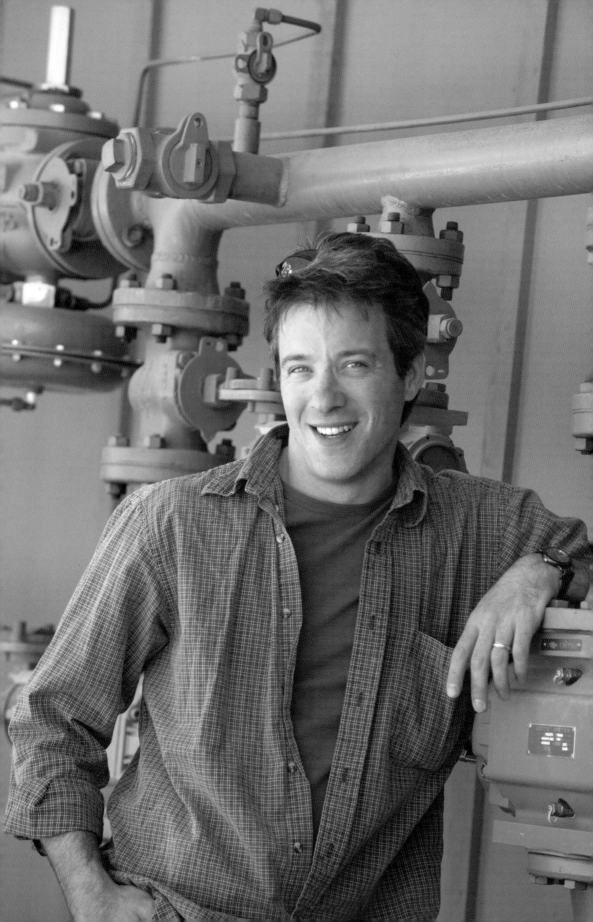

In the images on the facing page and on the right, the environment and the pose work harmoniously to help set the mood of the portrait.

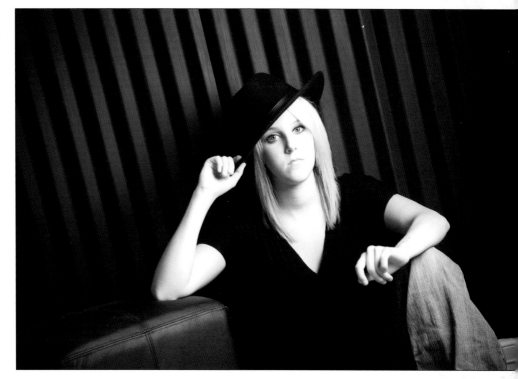

On the facing page, we have a great portrait of a man in a casual pose. We were walking around looking for great light and interesting places to photograph, and we found both. I wanted a very natural, casual pose to go with the subject's casual clothing. The gas pipes in front of the brown wall seemed to be the perfect place. Note that the subject's shoulders are at an angle to the camera, and his head is turned and tilted toward the light. This is a classic "masculine" or C-shaped pose.

In the image above, we have an interesting camera angle and lots of graphic appeal. All of the elements present dynamic lines, giving the image energy. Both arms are bent, the fingers are gently curled, and the teen's right arm directs the viewer's gaze to the subject's face. The sharp contrast of the subject's skin with her clothing also reinforces the visual prominence of the subject.

Resources

Education
Books
 www.amherstmedia.com
Online Forums
 www.prophotogs.com
 www.pro4um.com
 www.texasphotoforum.com
Photo Schools
 http://ppa.com/education-events/schools.php
 www.texasphotographicworkshops.com
 www.texasschool.org
Professional Organizations
 www.tppa.org
 www.ppa.com
 www.wppi-online.com
 www.photoshopuser.com

Equipment
Camera Equipment
 www.arlingtoncamera.com
 www.houstoncameraexchange.com
 www.mpex.com
Crop Lines in Camera
 www.croplines.com
The "Doug Box" (Softbox)
 www.thedougbox.com
 www.texasphotographicworkshops.com
Light Boxes
 www.larson-ent.com
 www.profoto.com
Lighting
 www.profoto.com
Light Meters
 www.macgroupus.com

Modular Photo Equipment Belt
 www.kgear.com
Rolling Equipment Case and Camera Bags
 www.macgroupus.com
 www.portercase.com
Tripods
 www.bogenimaging.com

Image Editing Software/Equipment
Graphics Tablets
 www.wacom.com
Photoshop Plug-ins
 www.kevinkubota.com
 www.niksoftware.com
 www.onone.com
 www.ronnichols.com
Studio Management Software
 www.photoonesoftware.com
 www.successware.net

Photo Lab
www.acilab.com

Portrait Products and Supplies
Albums
 www.albumsinc.com
 www.wgbooks.com
 www.forbeyon.com
Boxes
 www.paperboxandspecialty.com
Foil Stamp Machines
 www.veachco.com

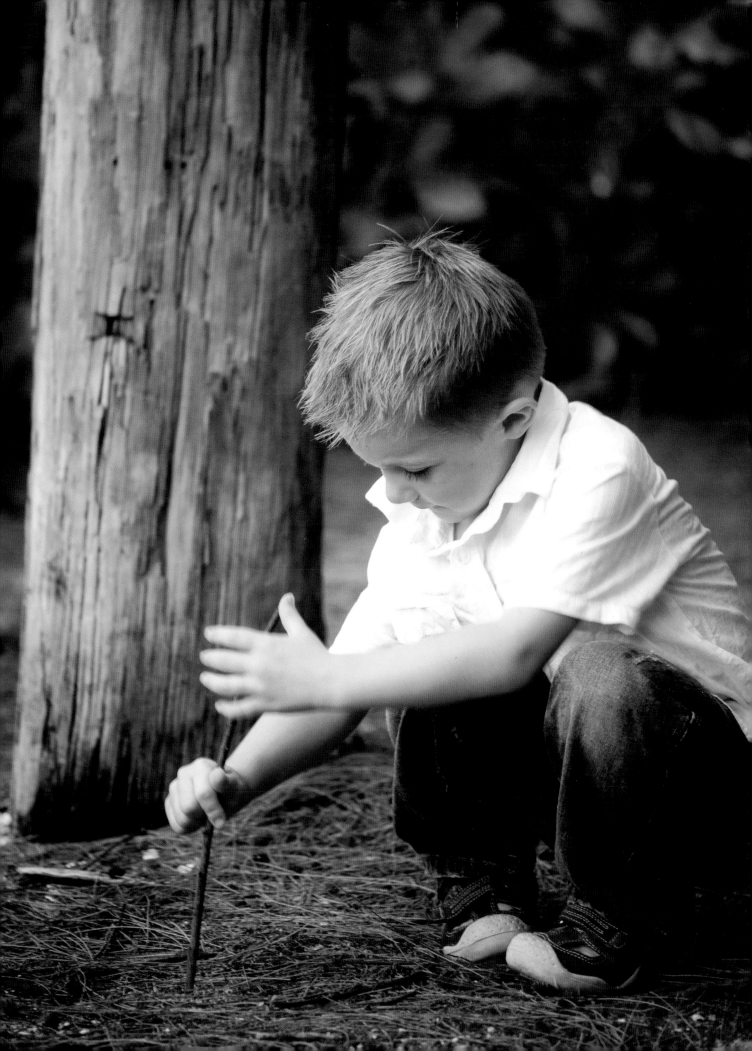

Frames
 www.burnspictureframe.com
 www.gwmoulding.com
 www.epocharts.com
Labels
 www.centurylabel.com
Photo Christmas Cards
 www.acilab.com
 www.stylart.com
Photo Inkjet Paper
 www.kodak.com
T-Shirts, Hats, Bags, etc.
 www.customink.com

Marketing and Sales Tools
Bulk E-mail
 www.constantcontact.com
Software (ProSelect)
 www.ronnichols.com
 www.timeexposure.com
Web Sites
 www.marathonpress.com

Miscellaneous
Backgrounds
 www.madcamp.biz
 www.shootinggallerybackgrounds.com
 www.silverlakephoto.com
Digital Mats
 jhartman@coredcs.com
Props
 www.aprprops.com
 www.dennymfg.com
 www.wickerbydesign.com
Royalty-Free Music
 www.graniteaudiopro.com
 www.musicbakery.com
 www.garylamb.com

Index

DOUG BOX'S

Off-Camera Flash

TECHNIQUES FOR DIGITAL PHOTOGRAPHERS

Master off-camera flash, alone or with light modifiers. Box teaches you how to create perfect portrait, wedding, and event shots, indoors and out. *$34.95 list, 8.5x11, 128p, 345 color images, index, order no. 1931.*

Professional Secrets of Wedding Photography, 2nd Ed.

Douglas Allen Box

Top-quality portraits are analyzed to teach you the art of professional wedding portraiture. Lighting diagrams, posing information, and technical specs are included for every image. *$29.95 list, 8.5x11, 128p, 80 color photos, order no. 1658.*

PROFESSIONAL TECHNIQUES FOR

Natural Light Portrait Photography

Douglas Allen Box

Use natural light to create hassle-free portraiture. Beautifully illustrated with detailed instructions on equipment, lighting, and posing. *$34.95 list, 8.5x11, 128p, 80 color photos, order no. 1706.*

Master Posing Guide for Portrait Photographers

J. D. Wacker

Learn to pose single portrait subjects, couples, and groups for studio or location portraits. Includes photographing weddings, sports teams, children, special events, and much more. *$34.95 list, 8.5x11, 128p, 80 photos, order no. 1722.*

Posing for Portrait Photography

A HEAD-TO-TOE GUIDE

Jeff Smith

Author Jeff Smith teaches surefire techniques for fine-tuning every aspect of the pose for the most flattering results. *$34.95 list, 8.5x11, 128p, 150 color photos, index, order no. 1786.*

Professional Model Portfolios

A STEP-BY-STEP GUIDE FOR PHOTOGRAPHERS

Billy Pegram

Learn to create portfolios that will get your clients noticed—and hired! *$39.95 list, 8.5x11, 128p, 100 color images, index, order no. 1789.*

THE PORTRAIT PHOTOGRAPHER'S

Guide to Posing

Bill Hurter

Posing can make or break an image. Now you can get the posing tips and techniques that have propelled the finest portrait photographers in the industry to the top. *$39.95 list, 8.5x11, 128p, 200 color photos, index, order no. 1779.*

Master Lighting Guide

FOR PORTRAIT PHOTOGRAPHERS

Christopher Grey

Master traditional lighting styles and use creative modifications that will maximize your results. *$34.95 list, 8.5x11, 128p, 300 color photos, index, order no. 1778.*

JEFF SMITH'S

Posing Techniques for Location Portrait Photography

Use architectural and natural elements to support the pose, maximize the flow of the session, and create refined, artful poses for individual subjects and groups—indoors or out. *$34.95 list, 8.5x11, 128p, 150 color photos, index, order no. 1851.*

500 Poses for Photographing Brides

Michelle Perkins

Filled with images by some of the world's best wedding photographers, this book can provide the inspiration you need to spice up your posing or refine your techniques. *$34.95 list, 8.5x11, 128p, 500 color images, index, order no. 1909.*

The Art of Posing

TECHNIQUES FOR DIGITAL PORTRAIT PHOTOGRAPHERS

Lou Jacobs Jr.

Create compelling poses for individuals, couples, and families. Jacobs culls strategies and insights from ten photographers whose styles range from traditional to modern. *$34.95 list, 8.5x11, 128p, 180 color images, index, order no. 2007.*

Corrective Lighting, Posing & Retouching

FOR DIGITAL PORTRAIT PHOTOGRAPHERS, 3RD ED.

Jeff Smith

Address your subject's perceived physical flaws in the camera room and in postproduction to boost client confidence and sales. *$34.95 list, 8.5x11, 128p, 180 color images, index, order no. 1916.*